Eugenia & John

IMAGES of America
GREEKS IN CHICAGO

Dear Eugenia & John,

There are too many stories to tell about Dad & Mom, but we were able to record one or two incidents.

Dad's & Mom's generation is also "the greatest generation" because they too endured many hardships and successes.

Enjoy!

Love,
Dena

Andrew T. Kopan, Ph.D. (1924–2006), longtime educator at DePaul University, was a towering figure of scholarship and erudition in the Greek community in Chicago. Through the efforts of Kopan, some of the photographs in his large collection have been represented in the images in Greeks in Chicago. (Courtesy of the Andrew T. Kopan collection.)

On the cover: In 1933, on Northerly Island, the Chicago world's fair set aside a day to honor the Hellenic heritage of Chicago's Greek population, and the Orthodox Christian clergy of Chicago gathered to celebrate the contributions of Greeks to the life of the city. In the full photograph, the father of writer Harry Mark Petrakis, Rev. Mark (Marcos) Petrakis, is standing in the front row. (Courtesy of the Hellenic Museum and Cultural Center.)

IMAGES of America
GREEKS IN CHICAGO

Michael George Davros, Ph.D.

Copyright © 2009 by Michael George Davros, Ph.D.
ISBN 978-0-7385-6171-4

Published by Arcadia Publishing
Charleston SC, Chicago IL, Portsmouth NH, San Francisco CA

Printed in the United States of America

Library of Congress Catalog Card Number: 2008926390

For all general information contact Arcadia Publishing at:
Telephone 843-853-2070
Fax 843-853-0044
E-mail sales@arcadiapublishing.com
For customer service and orders:
Toll-Free 1-888-313-2665

Visit us on the Internet at www.arcadiapublishing.com

To Vivian, my wife, and to my children, Athena, George, and Dino, and to Christopher and his wife, Wendy. Their patience has matched my impatience, and without their help, this book would not have been possible. I have relied on them as inspirations and technological and emotional support staff. To paraphrase William Wordsworth, sometimes child is father to the man.

CONTENTS

Foreword		6
Acknowledgments		7
Introduction		8
1.	Migration and Immigration	11
2.	The Early Years	17
3.	Family Life	27
4.	Business and Work	35
5.	Tradition and Community	53
6.	The Churches	67
7.	Social and Fraternal Organizations	83
8.	Arts, Culture, and Recreation	93
9.	Notable Greeks in Chicago	109
10.	Preservation and the Backward Glance to the Homeland	121

Foreword

In 2002, Prof. Andrew T. Kopan and Alice Orphanos Kopan began an endeavor to produce a history of the Greek community in Chicago. Professor Kopan, a distinguished and much-published scholar, historian, and activist, was especially sought after as an internationally recognized authority on ethnicity, multiculturalism, and Orthodox Christianity. Alice Orphanos Kopan, an educator and administrator with extensive work as an editor and textbook author, brought her own diverse professional experiences within the Greek American community to the project.

The Kopans, active in the Greek American community throughout the United States, worked vigorously on activities and publications focusing on educational, religious, and civic concerns. Professor Kopan's sudden illness and subsequent death in 2006 unfortunately led to the end of their publishing endeavor.

Greeks in Chicago does reflect a small fraction of Professor Kopan's thousands of photographs and documents. The lengthy captions to photographs identified as "courtesy of the Andrew T. Kopan collection" were ably adapted by Michael George Davros, Ph.D.

Professor Kopan was passionate and tenacious about the importance of the retention of historical archives, which become part of a community's collective memory and heritage. Materials given to repositories, such as universities and museums, provide convenient access to both scholars and the public and avoid the risk of being lost and forgotten by future generations. Much of his voluminous collection of personal papers continue to be classified and preserved at DePaul University's special collections library in Chicago and can be accessed online. Additional collections are being assembled at the Hellenic Museum and Cultural Center in Chicago. Professor Kopan was one of the founders of the museum and served as the first chairman of the museum's organizing committee.

Professor Kopan's research reinforced the fact that ethnic survival is not static and knowledge of a group's struggles and triumphs of the past give valuable insight for the preservation of cultural and religious legacies. Over the years, he urged that strategic and collective community intervention is essential for any ethnic group to survive and be vibrant over time, especially past the fifth generation.

Despite the lessening ethnic bonds of each successive generation, it was Professor Kopan's intention to end their history on the Greeks of Chicago with these words:

> And so the tradition continues . . . for over 100 years the Greek American community of Chicago has been expressing its loyalty to America and American ideals and dedication to its Hellenic heritage. As we enter this 21st century, the Greeks of Chicago continue to maintain a remarkable degree of ethnic community and family cohesion while also comfortably accommodating to the achievement standards of mainstream America. For now, this almost self-congratulatory "best of two worlds" adaptation may well be the distinguishing mark of the Greek presence in Chicago if not the broader Hellenic community nationwide.

—Alice Orphanos Kopan, August 2008

ACKNOWLEDGMENTS

Seldom is a work of the complexity of *Greeks in Chicago* the product of a singular effort. The number of images available for this kind of project is truly staggering, and a dedication to a faithful, accurate, and representative history places unique demands on the individual masquerading as historian. Although this book is not an exhaustive study, it may prompt additional research and discovery of the legacy of Greeks in Chicago. Recognition goes to the following people who supplied images or historical information: Helen Alexander, Peter Alexopoulos, James Apostol, Louis G. Apostol, Andrew A. Athens, Constantine Bacil, Emmanuel Andrew Bennett, Phil Bouzeos, Margaret E. Boylan, Mary Jo Cally, James Newport Chiakulas, Dena Colovos, Constance M. and Robert N. Constant, Roy Dolgos, Vasiliki Davlantes Domer, Milton and Catherine Fasseas, Deborah and Peter Gallios, Paula Kachoris, Adeline Kalant, Economos Proistamenos John N. Kalomas, Patricia Kamberos, Irene Kaporis, Maria Karamitsos, Theodora and Nick Kontos, Ethel Kotsovos, Protopresbyter Proistamenos Emeritus John G. Kutulas, Em Lee Lambos, George Lekas, Denise Maniatis, George L. Mazarakos, Katina Mendieta, Terry Mikuzis, Peter S. Pagratis, Irene and Caroline Panagopoulos, Harold and Faye Peponis, Yvonne Philippidis, Helen, Thomas, and Alexander Potakis, John Psiharis, Diane and William Rouman, Sophia and Trent Sarantis, Katherine G. Siavelis, George Sinadinos, Steve and Sondra Tremulis, Frances and Themis Tsaoussis, and Lily Pagratis Venson. Panos and Irene Fiorentinos shared their experiences of constructing *Ecclesia: Greek Orthodox Churches of the Chicago Metropolis*. Special gratitude goes to Terry Poulos, journalist with the *Greek Star*, and James Michael Mezilson, a journalist serving the Chicago Greek community for over 60 years.

The assistance of Allison Heller, collections manager of the Hellenic Museum and Cultural Center in Chicago, has been very valuable.

I greatly appreciate the patience and advice of my editors at Arcadia Publishing, John Pearson and Melissa Basilone, who granted an extension so that I could conduct a classics study tour in Greece with students from Northeastern Illinois University.

Finally, I reserve deepest debts of gratitude and appreciation for Steve Frangos, journalist with the *National Herald*, and Alice Orphanos Kopan, educator and author. Without the collection of photographs and text of the late DePaul University professor Andrew T. Kopan, the completion of *Greeks in Chicago* would have been impossible. The collegial assistance of Steve and Alice as we sifted through photographs and papers recollected the history of the century, and I treasure the friendship that has resulted.

INTRODUCTION

In the early years of Greek immigration to the United States, many immigrants came to the United States with the belief that their stay was temporary. This ethos persisted for many Greeks into the middle of the 20th century. However, many Greeks came to stay and were directed by a daily work ethic that went beyond the 40-hour week. Greeks were capable of the backbreaking labor of the railroads and the long hours of the horse carts, grocery stores, and restaurants, but work served the purpose of achieving prosperity. While the monuments in the new world of American enterprise would not be in marble, Greeks would still achieve in business, industry, and the arts, but achievement began in the humble beginnings of relatively few immigrants.

Grocers, confectioners, businesspeople, and a few professionals would be produced from the simple horse-cart drivers. Peddlers abounded in the early century and persisted as late as the 1950s. From a grocery store or ice-cream parlor acquisition, real estate fortunes developed, particularly as one generation provided wealth for the next. Greeks not only worked long hours, but they demonstrated faith in the future when children of immigrant parents entered professions. Doctors, attorneys, professors, and many professions associated with high status and income emerged as parents placed high valuation on education.

The family provided a framework for success. Greek families centered children in cultural transmission of myth, literature, philosophy, even of sayings and jokes that teach children the pitfalls of pride. For many immigrants, though, family life was disrupted. Often children were sent to the United States unattended to meet brothers or family. Brothers often arrived in the country years before a relative. Often a sister in Greece would need to be married, so a brother, established in the United States, provided the means to ensure a successful marriage. Men would arrive in the United States and send as much of their income to the homeland either for *pryka* (dowry) or to support a family. In the United States, family life also involved education, and church-sponsored Greek day and afternoon schools arose to meet the needs to educate children in both languages. Education turned toward preservation of the Greek language. The fear that the Greek language would disperse was accompanied by the fear that the core of Hellenic culture and ideals would disappear. Greek schools and language instruction today act in defense and preservation of Greek culture.

Of work, faith, and education, the driving force of accomplishments in the Greek community was work. The scene has been oft repeated: the pushcart driver, the hot dog vendor, and the street peddler put their daughters through college. While the Horatio Alger scenario unfolds for the Greek as well as the average American, Greek Americans have used the marketplace and the marketplace of ideas to vault to prominence and success. The valuation placed on work led Greek Americans to deposit wealth not only into business institutions but also the churches and then into political arenas.

As Greeks established themselves in business, professions, and politics, philanthropic activities, always present, accelerated. Understanding that the United States provided a haven to Greeks who were or had been in desperate circumstances encouraged Greeks to give back to their adopted country. Military service and public service were also emphasized as Greek

Americans rose in the political and labor spheres and pushed public officials to recognize the precarious political circumstances of the homeland. For many Greeks, the desire to return to the homeland for permanent residence had abated, especially during World War II, but Greek Americans realized responsibilities to the homeland. Thus, as Greeks recognized their ancient and magnificent past, they also understood the need to show American communities some of that glorious heritage. Celebrations, parades, and festivals were very public, and community service organizations confronted the specific needs of Greek Americans. Toward the end of the century, Greek Americans had become more concerned with the preservation of heritage and history, and institutions to preserve and memorialize the contributions of the Greeks began to proliferate.

The Greek Orthodox faith provided another sanctuary, and the priest's intonation to the congregation during liturgy, "with fear, faith, and love draw near" to receive the sacrament of Holy Communion, suggests the devotion and humility with which Greeks brought their own gifts to the churches. As churches grew into magnificent and ornate structures, Greeks expended great wealth to establish thriving Greek Orthodox communities throughout Chicago. With suburban expansion, more Greeks committed funds to build new parish buildings and managed their governance through adept parish councils. Today, while approximately 70 percent or more Orthodox marriages unite one in the couple who is non-Orthodox, the church has remained a bulwark against social upheavals, taking pride in maintaining a direct line in the apostolic succession to the apostle Andrew.

Supporting the Greek network of faith and work, social and fraternal organizations coalesced. The missions of these organizations shifted during the century so that by the end of the century more organizations were devoted to preservation of culture and language. Many organizations were political while others attempted to preserve a loyalty to a particular region of the homeland. Greater socioeconomic mobility fostered emergence of professional societies such as the Hellenic Bar Association, Greek University Women's Club, Hellenic Dental Society, and the Hellenic Police Officers Association.

Churches also created societies. Women's clubs transformed themselves into the Philoptochos (literally "friends of the poor") to address growing problems of poverty both inside and outside the Greek community and the United States.

In literature, painting, sculpture, the fabric arts, film, cuisine, theater, education, music, politics, the arts, medicine, engineering, athletics, and automotive design, Greeks have lived up to the moral imperative of their heritage. While many modern Greeks may not readily identify the concept of *arête*, the strive toward excellence certainly manifests itself in cultural productions. In Chicago, operas were even produced at midcentury, some of them designed to assist in the war effort. More than a few Greeks opened movie theaters, conversions from vaudeville. Ever-increasing wealth brought about higher aspirations so that seeing big-name Greek surnamed performers is not unusual.

Thus, Greeks have stood out by their accomplishments and by their political involvement, and to recognize all those worthy of recognition would be to signify an entire population with ancient roots. Those roots have provided a strong system to accelerated achievement.

Finally, the glance of the American Hellene is ever backward, if not to the homeland, then to the classical ideals that inspire much pride and even a cultural imperative to succeed and to attain what the classical mind called arête. Arête is more than just style points on the high dive. It is how one does things. As many Greek Americans acquired wealth, they contributed money to Greeks in Europe. American Greeks have benefitted their European counterparts by building roads, orphanages, hospitals, clinics, and other services. Recent efforts, like those of Andrew A. Athens to benefit people who identify themselves as Greeks in the former republics of the Soviet Union, have met with dramatic benefits for an oppressed people.

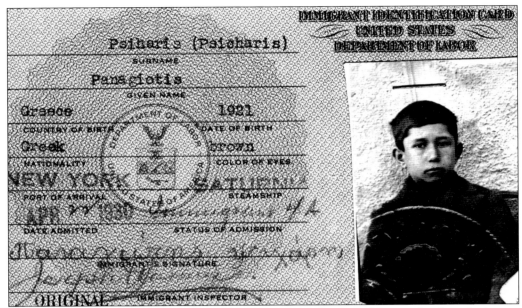

Peter (Panagiotis) Psiharis, on April 22, 1930, is admitted to the United States after disembarkation from the SS *Saturnia*. The voyage across the Atlantic Ocean, often punctuated by rough seas, did not dissuade Greek immigrants from coming to the United States. Not uncommonly, parents sent their youngsters, in this case a nine-year-old boy, to fend for themselves. The immigrant identification card was issued by the United States Department of Labor. (Courtesy of John Psiharis.)

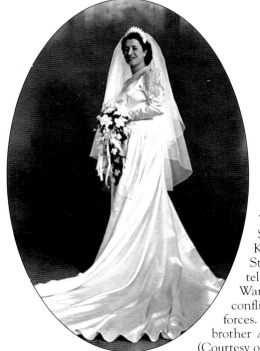

The February 27, 1949, wedding photograph of Sophia Lamperis who married Constantinos Karapanos (who arrived in America in 1914) at St. Spyridon Greek Orthodox Church in Chicago, tells a story of Greek immigration after World War II. War-torn Greece was plunged into a Civil War conflict between Communist and anti-Communist forces. Lamperis was sent by her mother to live with brother Alex on the South Side to make a better life. (Courtesy of Helen and Thomas Potakis.)

One
MIGRATION AND IMMIGRATION

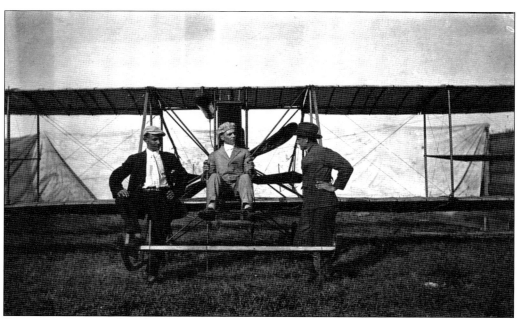

Some men came to America for reasons other than earning a *pryka* (dowry) for sisters. Peter Colovos (1893–1955), center, came to learn to fly biplanes. On August 22, 1912, he was granted certificate membership No. 160 in the Fédération Aéronautique Internationale, the governing authority for the United States. Later in 1912, he returned to Greece to fight in the Balkan Wars and was instrumental in establishing the nascent Greek air force. (Courtesy of Dena Colovos.)

Theodore Koliakos, an early arrival from Sparta in 1888, first used a produce pushcart, a horse cart, then had a street corner stand, and finally a storefront confectionery business at Fifteenth Street and Michigan Avenue. He made the 35-day crossing over the Atlantic Ocean at least three times while his wife and eventually five daughters remained in Greece. He would fund his daughters' wedding dowries with money he earned in Chicago. (Courtesy of Katherine G. Siavelis.)

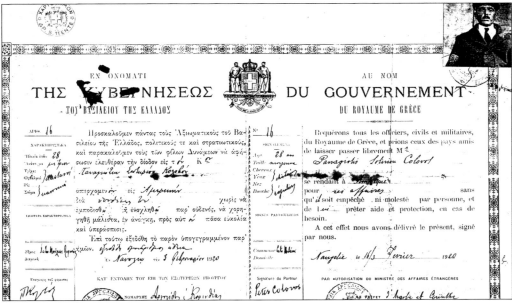

In 1920, Peter Colovos returned to the United States and began a grocery business on Chicago's North Side. His immigration papers, in Greek and French, signed in Nauplion, Greece, in 1920 and bearing the seal of the king of Greece, gave him permission to travel to the United States. During the Depression, he helped found the Society of Lyrekia Argos to assist families in need. (Courtesy of Dena Colovos.)

Peter Colovos's 1926 naturalization papers are a sign that while many immigrants came long enough to earn money to return to Greece, some came to stay and establish themselves as successful contributors in the American economy. (Courtesy of Dena Colovos.)

Four young men who emigrated from Mercovouni, Arcadia, Greece, before 1913, were working for little pay as shoe shine boys but dressed well to exude success to relatives in Greece. Photographs like these stimulated immigration. From left to right are (seated) Paul (Apostolos) Limberopulos and Ted Pappas (Euthimios Papadopoulos); (standing) Bill Limber (Vasilios Limberopulos) and Sam Pappas (Sotirios Papadopoulos). Paul Limberopulos became the owner of a diner, Austin Lunch, at 1458 West Madison Street, the setting of *Austin Lunch: Greek-American Recollections* by daughter Constance. (Courtesy of Constance M. and Robert N. Constant.)

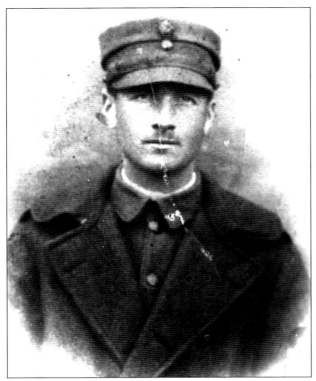

Before many Greek youths could make decisions about their lives, they met an obligation to military service. A village youth, the eldest of 14 children, was drafted out of the University of Athens. George Davros, at age 19 in a Greek army uniform, prepares for service during World War I around 1917. After sustaining a wound from Turkish gunfire on the island of Chios, he was honorably discharged, returned to his home, near Tripolis, the village of Matzagra (Agios Konstandinos). By 1922, he was successful in the grocery business in Chicago. (Author's collection.)

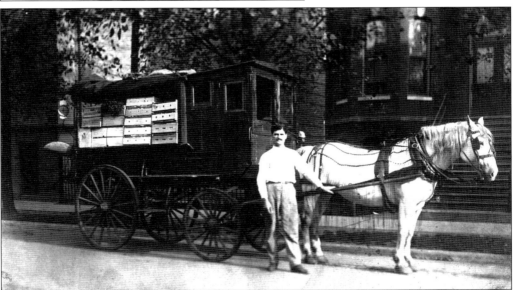

The horse cart of George Panagopoulos (in 1910) demonstrates the business prowess of immigrant Greeks. For many Hellenes arriving in Chicago between 1890 and 1920, horse cart peddling was a common occupation. In addition, Panagopoulos was one of the founding members of the North Shore chapter No. 94 of the American Hellenic Educational Progressive Association (AHEPA). Many horse cart drivers would stay in living quarters above the horses' stables. (Courtesy of Irene and Caroline Panagopoulos.)

Michael Lambos made several trips between Greece and the United States before settling in Chicago in 1912. His candy store and confectionery in the 1920s was well established on Michigan Avenue, across from the Illinois Central Railroad station. Candy, confectionery, and ice-cream-making businesses were common features in the early landscape of Greek immigrant businesses. (Author's collection.)

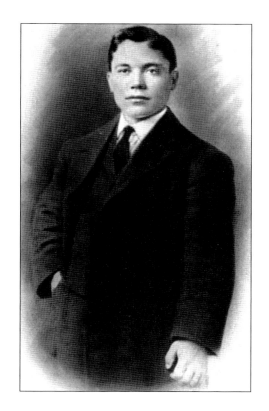

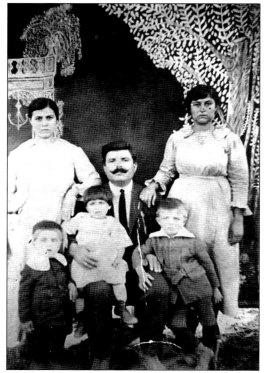

Michael Loukis and his family are pictured here in 1920 before he returned to Greece. When immigration laws changed, Loukis had to remain in Greece while his family was left in the United States to fend for itself. (Courtesy of Katherine G. Siavelis.)

The United Greek Orthodox Churches
OF CHICAGO
2704 W. CARMEN AVE., — CHICAGO, ILL.

THE ANNUNCIATION
1617 N. La SALLE ST.

ST. DEMETRIOS
2704 W. CARMEN AVE.

For devotion to our Fathers' Faith and for Services to our people, our ever mindful Community, the UNITED GREEK ORTHODOX CHURCHES OF CHICAGO, expresses its heart-felt gratitude to *Apostolos Mazarakos* PRESIDENT 1915-1919 and beseeches our Heavenly Father to bestow upon him and his descendants the blessings of His Church.

THE ANNUNCIATION
Priest

BISHOP OF

For the Trustees

A certificate of appreciation dated October 26, 1954, recognizes the contribution of Apostolos Mazarakos, parish council president from 1915 to 1919. The certificate reads, "the United Greek Orthodox Churches of Chicago," but only Annunciation Cathedral and St. Demetrios Greek Orthodox Church are specified. St. Demetrios was founded originally as a full-day parochial school for the Annunciation community. The churches averted a mortgage crisis in the 1940s, and in 1983, the United Greek Orthodox Churches of Chicago was dissolved. (Courtesy of George L. Mazarakos.)

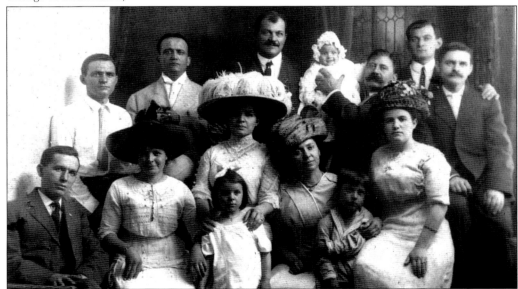

Proud father John Venson (Voutsanesis) holds son George as wife Virginia (first row, far right) and he are surrounded by close relatives, all from Greece, in 1910. John Venson opened one of the first grocery stores in the Howard Street area of Rogers Park in the early 1920s. Virginia's sister Sophia is in the first row on the far left. Early in the century, John emigrated from Sparta and Virginia from Athens. (Courtesy of Lily Pagratis Venson.)

Two
THE EARLY YEARS

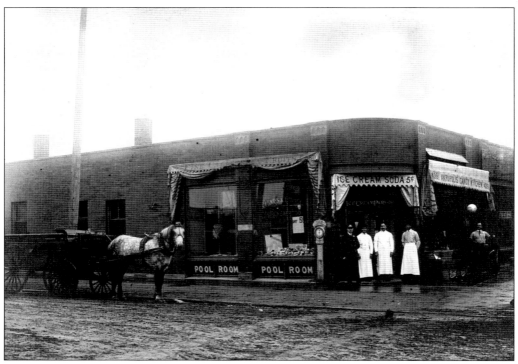

At the northwest corner of Clark Street and Devon Avenue, an unknown streetcar employee stands around 1905 with businessmen, from left to right, Peter Davlantes (1883–1970), George Roiniotis, Christ Davlantes, and Andrew Roiniotis (in shadow). The canopies read, "580 Fine California Fruits" and "4391 Akropolis Candy Kitchen." The Davlantes family is from Merkovouni, Tripolis, Greece. Peter, an orphan at a young age, arrived in the United States in 1896. (Courtesy of Vasiliki Davlantes Domer.)

Christine Ganoti Papageorge (1897–1975), born in Paleoxori, Greece, attended high school and college in the United States and may have been the first Greek person to teach in the Chicago Public Schools system. She taught at Dore School at Harrison and Halsted Streets. In 1915, her father owned a restaurant. (Courtesy of Diane and William Rouman.)

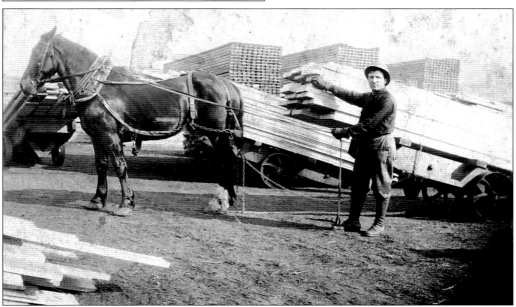

Testifying to one contention that horse-drawn peddlers were a ubiquitous presence on the streets of Chicago are the following two pictures of Harry Pappas, both taken in Chicago in 1910. In this photograph, Pappas is shown at a lumberyard. Single at the time, Pappas most frequently worked on the South Side. This photograph is the front side of a picture postcard, possibly designed for communicating to the relatives in the homeland. (Courtesy of Adeline Kalant.)

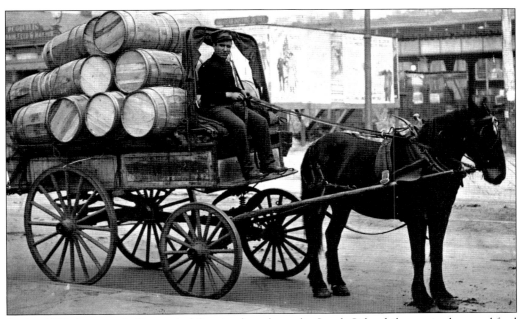

In this 1910 photograph, Pappas is delivering barrels on the South Side while a grain, hay, and feed business as well as elevated railway supports are in the background. (Courtesy of Adeline Kalant.)

Thomas Kanakis was one of 400 young Greek immigrants who returned to Greece at the outbreak of the Balkan Wars (1912–1913). While loyalties to the two countries may have divided early-20th-century Greeks, many returned. Kanakis did return, married, had a family, and successfully operated an egg and produce business. (Courtesy of Estelle Kanakis and the Andrew T. Kopan collection.)

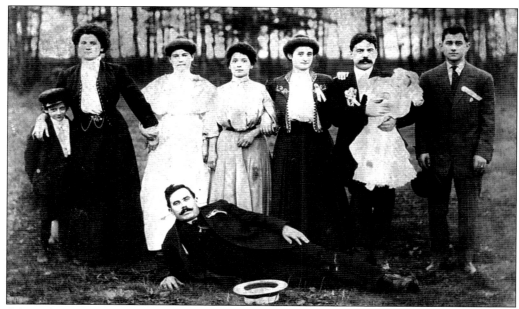

After a baptism, one of the seven sacraments in the life of an Orthodox Christian, this 1906 celebration began in a local park. Holding baby Blanche is father Chris Sikokis with the mother, Peloponnesia Sikokis, on his right. On the ground is Nicholas Maniatis. Lapel ribbons (*martirika*) are worn as signs, still in practice today, that attendees were witnesses to the rite. (Courtesy of Diane and William Rouman.)

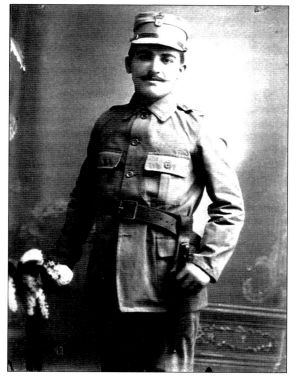

Paul Javaras, another returnee from the Balkan Wars of 1912–1913, was the founder and editor with Elias Georgopoulos of a weekly, the *Greek Press*, in 1929. As a young journalist, Javaras worked for Greek newspapers, including the *New Era* journal, published 1914–1924. In 1934, the *Greek Press* merged with *Thessaloniki*, which had been established in 1913. Javaras edited the *Greek Press* between 1934 and 1956, and the paper continues in publication. (Courtesy of the Andrew T. Kopan collection.)

After his arrival in 1908, George J. Manos eventually became a restaurateur at Chicago's South Water Market (1446 South Racine Avenue). Testifying to the value that Greeks have placed upon education are the careers of his sons: Nicholas G. Manos became an attorney and John G. Manos a theologian. (Courtesy of Nicholas G. Manos and the Andrew T. Kopan collection.)

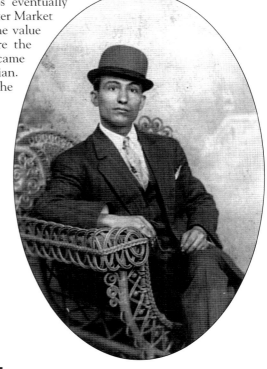

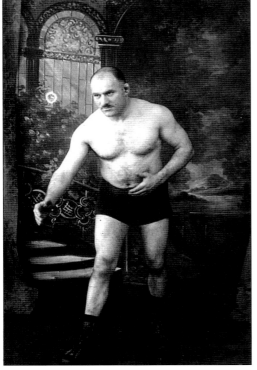

Seen here around 1900, wrestler Demetri Petihakes, "the Chicago Greek," traveled with a circus and also owned a restaurant. Greek wrestlers were commonplace on the American scene, particularly in the West after the American Civil War. In the middle of the 19th century, tall Greeks were admired as specimens of athleticism, and their persistence in professional wrestling continued into the middle of the 20th century. (Courtesy of the Hellenic Museum and Cultural Center.)

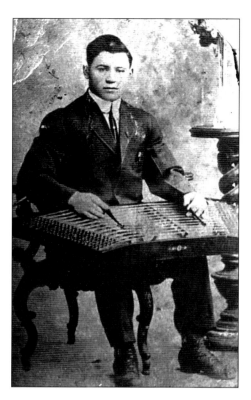

A resourceful Lucas Katsikas plays a santouri. He was born in 1893 in the village of Pentayiou in Roumeli. Katsikas learned to play the violin as a youth in Greece. After his arrival, he traveled with a small group of musicians entertaining section hands, laborers building railroads in the West. Balkan immigrants, Bulgarians, Macedonians, Greeks, Serbs, and Albanians, who were familiar with the sounds of their homelands, served as the audiences. (Courtesy of the Hellenic Museum and Cultural Center.)

Lucas Katsikas plays saxophone. After two years in San Francisco, playing in a Greek coffeehouse, he returned to Chicago, married Tassia Magemeneas, and played for weddings, baptisms, parties, dances, and picnics. He learned to play and teach 30 instruments. Whenever a booking required a particular instrument, he would learn to play it, whether drum, saxophone, santouri, or other instrument. He taught his young children many instruments. (Courtesy of the Hellenic Museum and Cultural Center.)

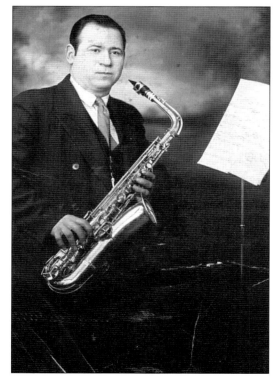

In the top portion of this modest wedding invitation in Greek, the fiancé (Nicholas Panagiotis Vitogianis) invites guests to the wedding while in the bottom portion the brother (Nicholas Spartianos) of the bride (Diamanto Spartianou) invites guests to gather at the bride's house at 311 South Ashland Avenue at 2:00 p.m. to go to Holy Trinity Greek Orthodox Church at 1101 South Peoria Street for the wedding at 2:30 p.m. on February 24, 1918. (Courtesy of Sophia and Trent Sarantis.)

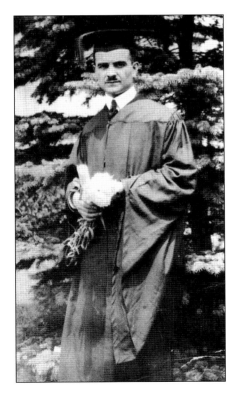

Among the many physicians of Greek descent, Dr. S. D. Soter (Speros Demetriou Soterakos, 1892–1982) arrived in Chicago in 1906 and, with the financial help of two brothers, attended the University of Wisconsin, graduating with a bachelor's degree in 1916. In 1922, pictured here in regalia, he graduated from Northwestern University Medical School. Living near Hull House, he was acquainted with a supporter of his work, Jane Addams. Most of his career was spent with the Chicago Board of Health. (Courtesy of Cynthia Soter Gouvis and the Andrew T. Kopan collection.)

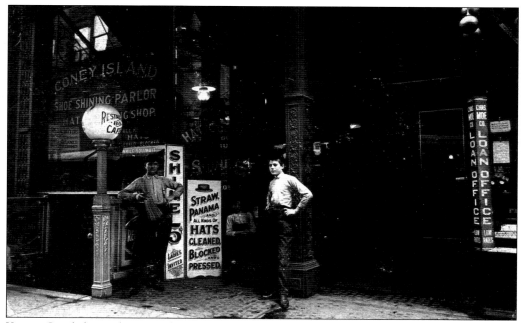

Young Greek boys also served in the shoe shine trade around 1912. At Coney Island Shoe Shining Parlor and Hat Cleaning Shop stands Nicholas Spartin (Spartianos), with whisk broom, who came from the village of Agios Vasilios in the Peloponnese, central Greece. (Courtesy of Sophia and Trent Sarantis.)

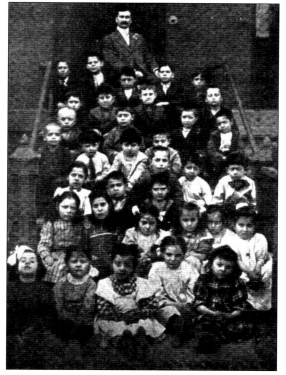

The Socrates School, a day school still in operation, opened on May 4, 1908. It was the first Greek day school in America to be sponsored by a Greek Orthodox parish, Holy Trinity Greek Orthodox Church, in Chicago. Pictured with the first students is George Arvanitis, the school's first teacher-principal. (Courtesy of the Andrew T. Kopan collection.)

Greek immigrants were enthusiastic sports participants as residents of Hull House. In 1914, marathon runner John T. Costopoulos (right) and Thomas Chakinis founded the Greek Olympic Athletic Club, which had exclusive use of the Hull House gymnasium. From this group, athletes including Jim Londos, Spiros Vorres, George Nikas, George Barbos, and Andrew Kallis emerged and attained national reputations. Thomas Chakinis was also a survivor of the *Eastland* disaster. (Courtesy of Mae Chakinis Panoplos and the Andrew T. Kopan collection.)

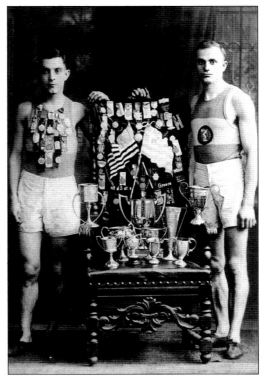

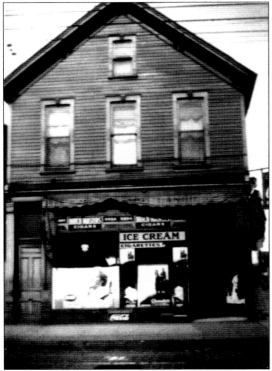

Apostolos Mazarakos opened this ice-cream parlor and confectionery, seen around 1910, at 1956 North California Avenue on April 1, 1899. The store sold both retail and wholesale. Mazarakos came to the United States in 1888 and helped the family of his brother after the brother died in 1927. According to his 1949 obituary, Mazarakos was an organizer of the first Greek American Republican organization in Cook County. (Courtesy of George L. Mazarakos.)

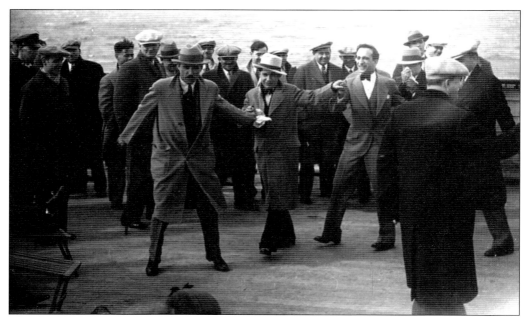

Because they were having a difficult time finding Greek wives in the United States in 1930, 150 Greek bachelors traveled back to the old country to find women who would be willing candidates. Many Greek families sent sons to America to become established and then to provide for female siblings. (Courtesy of George Sinadinos.)

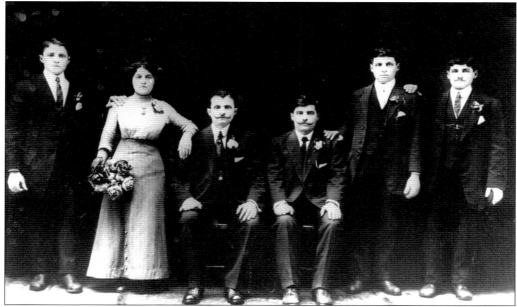

Of the Kamberos family (seen in 1920), from left to right, Gust Kamberos, Athanasia Kamberos Levent, Sam Kamberos, Tom Kamberos, Nick Kamberos, and Spiros Kamberos all went into the grocery business. Sam's sons opened the chain of Treasure Island grocery stores, which featured many ethnic specialty goods. Athanasia Levent opened Levent's Fish House and Banquet Hall in Whiting, Indiana. (Courtesy of Patricia Kamberos.)

Three
FAMILY LIFE

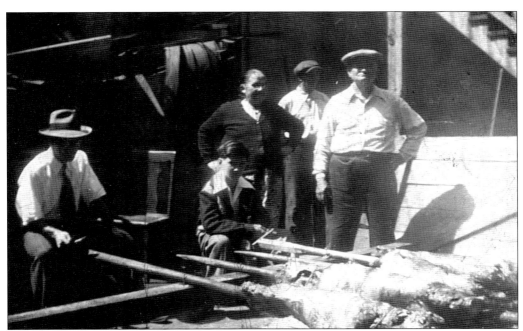

As part of the Easter celebration in April 1946, after fasting for 40 days, neighborhood Greeks walked behind the Akropolis Tavern and Restaurant at 644–646 Blue Island Avenue to purchase a roasted lamb for the feast. Peter Lalagos, the child, turns a wooden-handled spit. (Courtesy of Maria Karamitsos.)

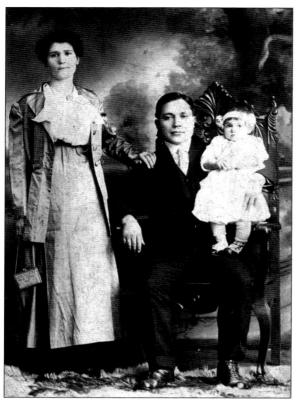

Many marriages were arranged either by families before the bride's arrival in the United States or afterward through family matchmaking, usually through a woman matchmaker (*proxenitria*). Pictured around 1916, Michael and Zoie Lambos with daughter Jeanne (Ioanna) opened a candy store and confectionery business on Michigan Avenue. The Lambos family would later lose its fortunes in business speculations. (Author's collection.)

The war years in Chicago (here in 1942) provided little time for relaxation. Here the children of the Lambos family pause for a picture. Jeanne and Em Lee, kneeling from left to right, are joined by, standing from left to right, Theda, Angelo, Helen, and Chris. While Angelo is preparing to leave for Glenview Naval Air Station, Chris awaits his assignment as gunnery mate in training in Alabama. (Author's collection.)

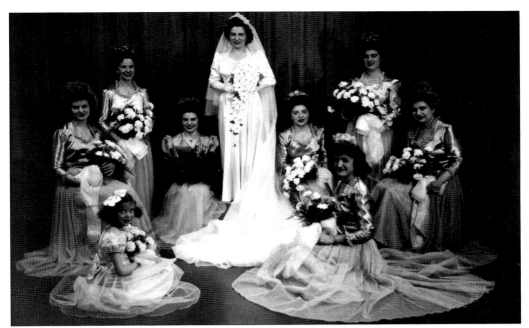

Despite the privations of World War II, this 1943 wedding seems to represent lavish display. The groom, George Davros, and the bride, Jeanne Lambos would not go on a honeymoon but would return to George's small apartment above his grocery store located on Bryn Mawr Avenue, on the city's North Side. The store, two blocks from starlit Edgewater Beach Hotel, was frequented by Hollywood performers and, before his incarceration, Al Capone. George's store was only two blocks from St. Andrew's Greek Orthodox Church. (Author's collection.)

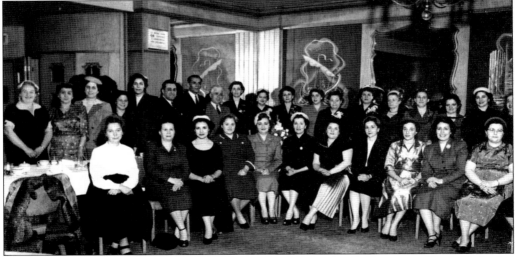

In 1952, the Parent-Teacher Association of Solon Greek School at St. Demetrios Greek Orthodox Church served a growing congregation on the northwest side. With the demolition of Greektown and rapid suburban expansion, Greek Americans moved north to create a new, smaller version of Greektown at Lawrence and Western Avenues during the 1960s and 1970s. St. Demetrios's numbers swelled, and in 1963, additional building space was constructed for classrooms, a gymnasium, a cultural center, and a library. (Courtesy of Milton and Catherine Fasseas.)

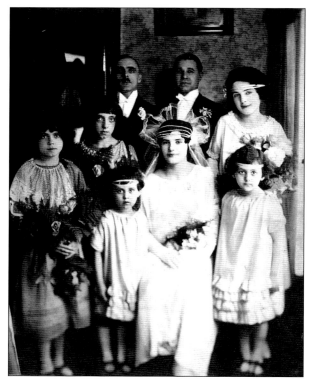

This May 1924 wedding photograph depicts, from left to right, Sophie Tarant Jackson, Annette Tarant Theodoratos, Evalyne Kokoris Larres, Peter Colovos (groom), Irene Kalantzis Colovos (bride), Sam Papas, Angeline Smeros Assimos, and Mary Kokoris Podesta (younger child). Peter Colovos immigrated to the United States around 1905 from Argos, Greece. During the Balkan Wars (1912–1913), he was a liaison between the Greek army/air force and the British. (Courtesy of Dena Colovos.)

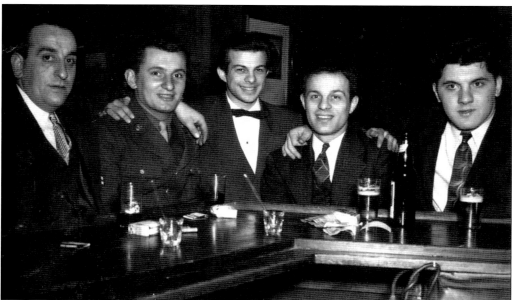

During World War II (here in 1943), soldiers and Chicago big band–era musicians enjoy time off at Ye Olde Tavern. From left to right are Peter Kraoulis, Nick Gallios, Nick Bliss, Jimmy Bliss, and Jimmy Gallios. Nick Gallios was home after basic training. Nick Bliss, a trumpet player, was also longtime president of the musicians' union of Chicago while Jimmy Bliss was a drummer. Cigarette and camera girl Kay Bliss photographed the group. (Courtesy of Deborah and Peter Gallios.)

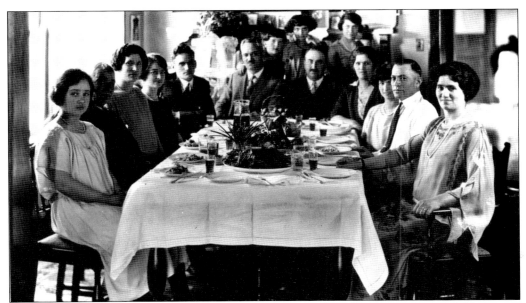

In 1924, 14 people are gathered in a North Side Chicago apartment on Springfield Avenue celebrating Easter Sunday. Of them, 13 are Greek immigrants, and the 14th, a neighbor's daughter, was invited because of the superstition with the number 13. Pictured are Stella and Manolis Damaskos, Aspasia Dimaras, Marigoula and John Papadakos, John Dimaras, sponsor of many of the guests, Nick, Mary, William, and Carrie Mitchell, and Nick Constant (Kostantopoulos). (Courtesy of Constance M. and Robert N. Constant.)

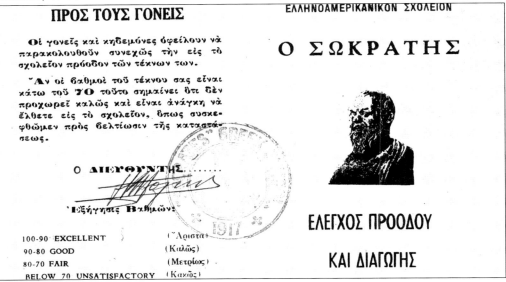

Many Greek American families took great pride in educating their children in both English and Greek and throughout the century enrolled children in some form of Greek education, including afternoon and evening schools. The curriculum of a Greek school included not only language but also culture and religion, especially for church-sponsored schools. As with American schools, Holy Trinity's Socrates School issued report cards for the school year (1975–1976). (Courtesy of John Psiharis.)

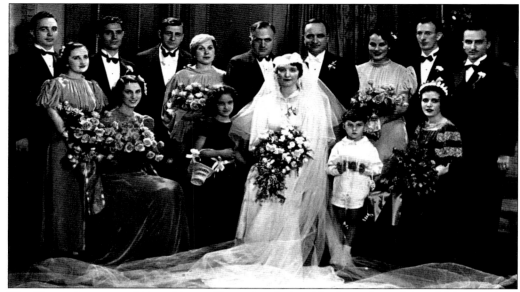

The Depression-era wedding of James Panagakis (behind bride to the right) and Mary in 1936 was to be followed by a long association of Panagakis with numerous businesses in three states, including theaters, restaurants, and a cable television company. Also in attendance with the wedding party is George Zoros, a furrier to the Greek community. (Courtesy of Diane and William Rouman.)

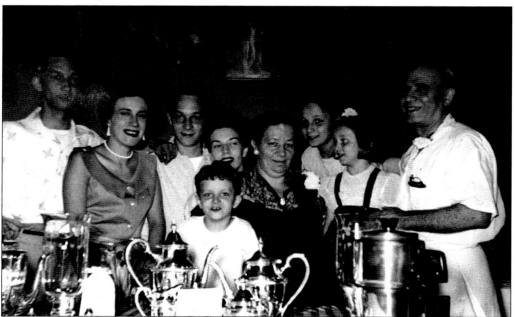

The Lalagos family is pictured here at a gathering in 1955. The marriage between James Lalagos (far right) and Eleni (fourth from right), which produced seven children, was arranged by a matchmaker (proxenitria). Mary, the bride's sister, and James, the groom, knew each other at Hull House three days before the wedding. True to classical roots, a framed picture of Praxiteles's sculpture *Hermes with the Infant Dionysos* hangs on the wall in the background. (Courtesy of Maria Karamitsos.)

In 1944, one portion of the Chrones (Polychrones) family is represented by Zaphirios and his wife Panagiota flanked by George and James (in uniform). The father owned and operated the North Side DeLazon Restaurant, a haven to intellectuals. George became associate judge of the circuit court of Cook County. James received his doctorate from Northwestern University and established himself as a professor of education at Chicago State University. (Courtesy of the Andrew T. Kopan collection.)

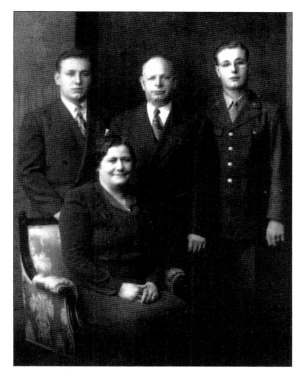

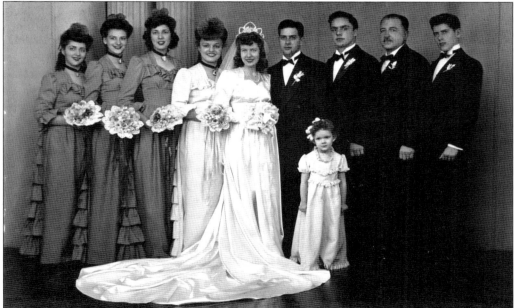

George and Lily Pagratis Venson were married in 1944 at the old St. Andrew's church at Hollywood and Winthrop Avenues. Their parents, Petros and Rozinia Pagratis and John and Virginia Venson, came to the United States in the early 20th century. Alexis Relias (second from right), known as "the Christmas Tree King," brought hundreds of Christmas trees to Chicago for sale by small vendors. He also brought trainloads of tomatoes from Mexico. (Courtesy of Lily Pagratis Venson.)

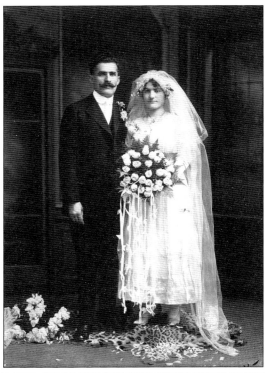

The wedding of Nicholas Vitogianis to Diamanto Spartianou in 1918 was conducted at Holy Trinity Greek Orthodox Church, 1101 South Peoria Street, with the reception at the West Side Auditorium at the corner of Taylor Street and Racine Avenue. The reception hall today would be in a business area between the east campus of the University of Illinois at Chicago and the west campus of the medical center. (Courtesy of Sophia and Trent Sarantis.)

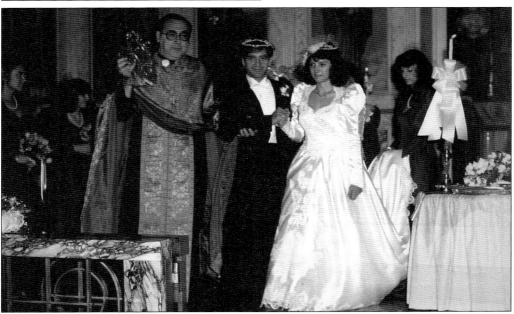

In the dance of Isaiah, a married couple takes their first steps together as husband and wife accompanied by the priest, Rev. Emmanuel Vergis at St. Demetrios Greek Orthodox Church on September 6, 1987. On the solea, the raised area in front of the iconostasion (icon screen), the couple follows the priest carrying the Holy Gospel to be reminded that they have chosen to walk through life accompanied by the Holy Trinity. (Author's collection.)

Four

BUSINESS AND WORK

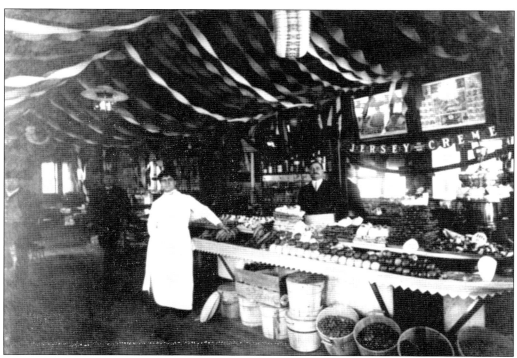

Peter Davlantes, in white apron, and cousin George Roiniotis (seen around 1905) operated a fruit, vegetable, cigar, and ice-cream store at 6400 North Clark Street in Chicago. When Davlantes arrived in 1896, Roiniotis was already in Chicago, but Davlantes went to work first for cousins in Nebraska and Iowa. As the four Davlantes and Roiniotis cousins acquired more property, they became successful in the real estate business. (Courtesy of Vasiliki Davlantes Domer.)

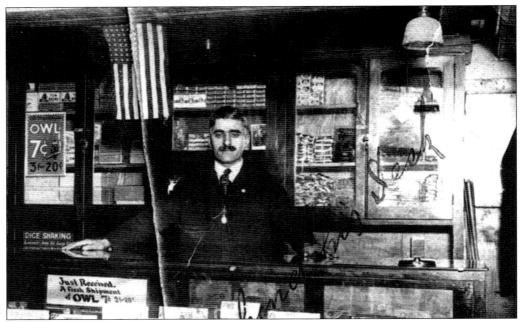

William Mitchell (Mihalopoulos) stands behind the counter of his restaurant in 1918. His son, Louis W. Mitchell, like many second-generation Greeks, took up the family business. Lou Mitchell built his restaurant into the world-famous Lou Mitchell's located at 563 West Jackson Boulevard in Chicago. Lou Mitchell lived to age 90. (Courtesy of Louis G. Apostol.)

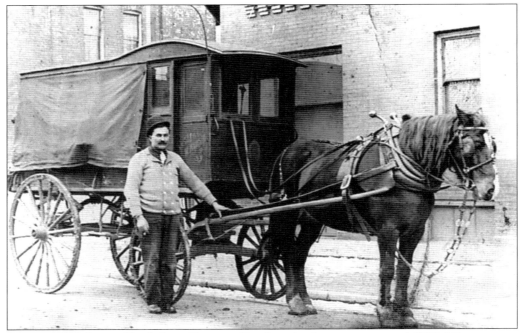

Horse peddler James Chiakulas sells vegetables from his horse cart around 1922. Like so many immigrants who came through Ellis Island, Chiakulas experienced a name change from the spelling of the family name in its original Tsiakoulas. (Courtesy of James Newport Chiakulas.)

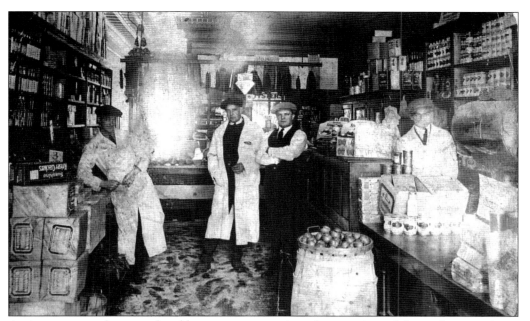

A picture postcard sent to the old country communicated prosperity and fostered greater desire for immigration. Constantine L. Malevitis (1903–1976), third from the left, the owner of a South Shore area Greek food market in 1924 at a scant 21 years old, displays the values of hard work and the entrepreneurial spirit. The sawdust on the floor was used as a common sanitation practice. (Courtesy of Louis Malevitis and the Andrew T. Kopan collection.)

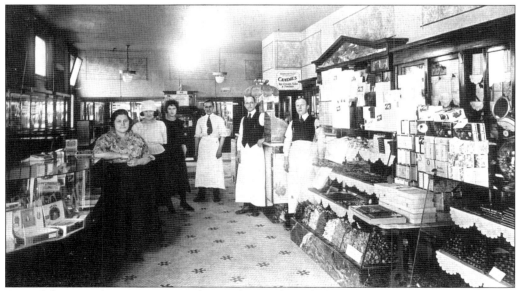

One of three candy stores co-owned around 1930 through the partnership of brothers Michael and Peter Mezilson, this one was located at 3101 South Halsted Street. The confectionery also sold wholesale to other stores. The three women at left are candy dippers, and all candies were hand dipped. The business was later moved to Sixty-third Street and Langley Avenue, across the street from White City Amusement Park. (Courtesy of James Michael Mezilson.)

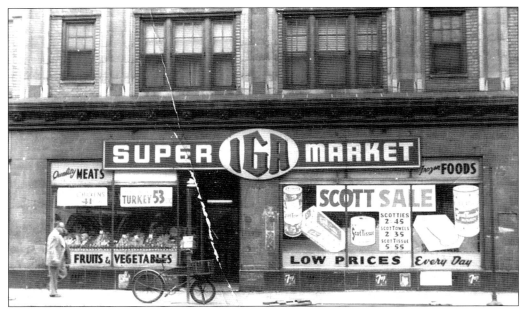

Taken during the early 1950s, this photograph depicts the first store acquired in 1926 by George Davros, who was born in approximately 1897 and died in 1981. Comparable to the 1920s storefront, the store's signs feature prices like chicken at 41¢ a pound and Scott Tissue rolls at five for 55¢. Parked in front of the store, the delivery bicycle with large front basket catered deliveries to the Edgewater Beach Hotel and nearby apartment buildings. (Author's collection.)

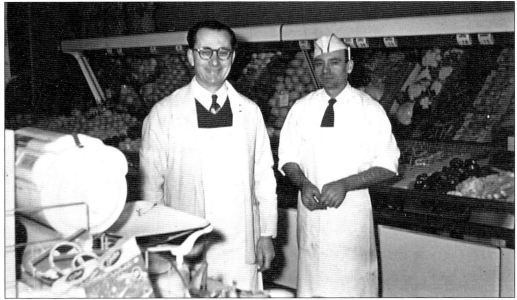

George Davros and his brother-in-law Stamatios Grevas stand in the produce aisle of the small store on Bryn Mawr Avenue in 1955. A typical practice would permit an established immigrant to sponsor a new arrival. Grevas (right) had arrived in America five years earlier with his son. Grevas would have to wait seven years to bring his daughter and wife to the United States. (Author's collection.)

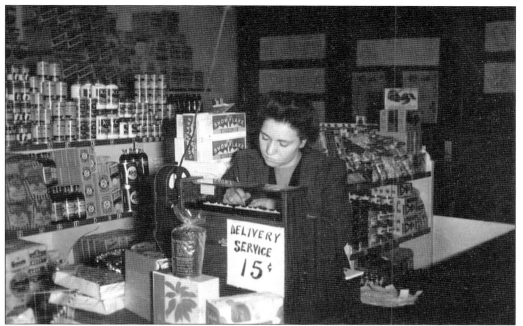

In the Super IGA Market, resemblances fade next to modern megastores. Cramped by stock and a cash register ancient even by 1946 standards, Jeanne Davros balances the evening's receipts. Usually open long hours, customarily 9:00 a.m. to 9:00 p.m., the store would close for significant holidays: Easter, Christmas, and Thanksgiving. (Author's collection.)

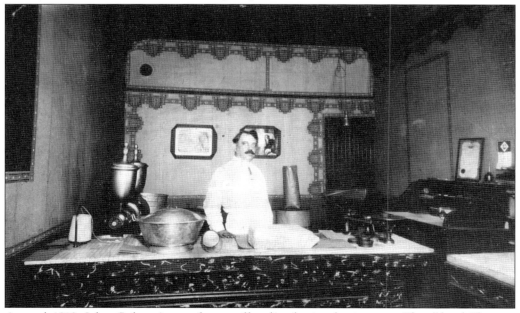

Around 1910, John Colovos's storefront coffee distribution business on Blue Island Place in Chicago's Greektown was a wholesale distribution operation that provided coffee to retail grocery stores and restaurants. The business is well equipped with grinders and scales. (Courtesy of Milton and Catherine Fasseas.)

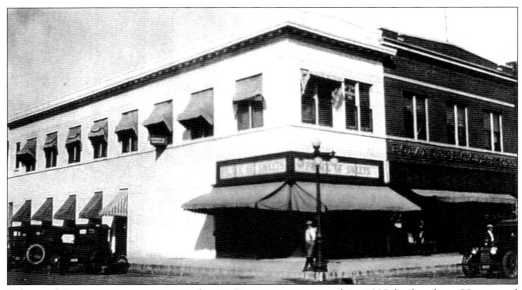

Palace of Sweets, an ice-cream parlor in Pontiac, was owned in 1927 by brothers Harry and Angelo Lappas with cousins Nicholas and Michael Chianakas. Relatives often helped one another in business. (Courtesy of Milton and Catherine Fasseas.)

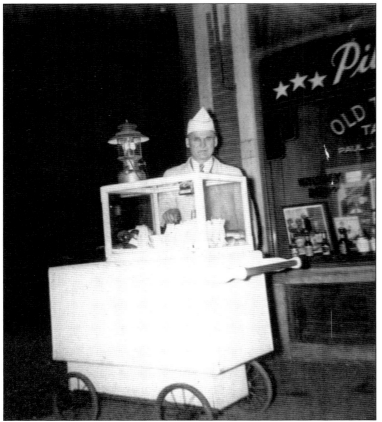

Hot dog vendor Pantelis Koulogeorges, seen in May 1942 in Chicago, was perhaps one of the last of a breed of street vendors. The street peddler sold not only hot dogs but produce and other goods that formed the foundation of Greek mercantile prominence in Chicago. Some vendors provided enough income to send children to college. (Courtesy of the Hellenic Museum and Cultural Center.)

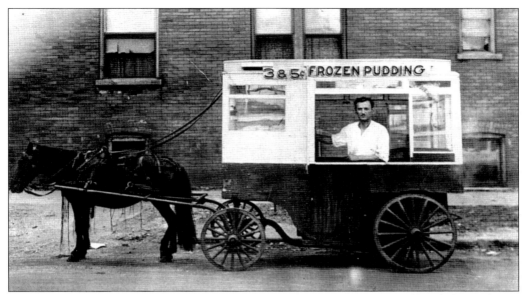

Among occupations supplanted by modernization was the selling of frozen pudding by horse-drawn cart. Seen around 1928, George Zaverdas from Klepa, Greece, evidently sold two sizes of pudding for 3¢ or 5¢. (Courtesy of the Hellenic Museum and Cultural Center.)

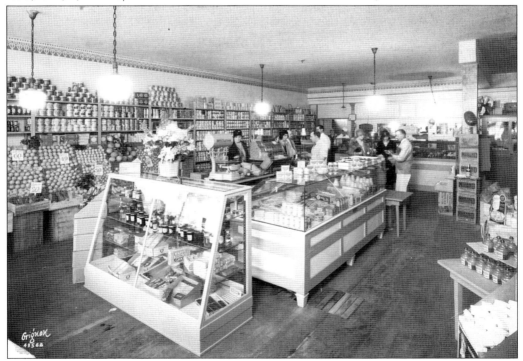

Featuring a very brightly lit shopping area with wooden floors, Peter Colovos's store at 1539 Howard Street in Chicago (seen around 1930) displays milk bottles in a very early dairy case. On display in the showcase in the foreground are imported foil-wrapped chocolates, jellies, and an assortment of cakes. (Courtesy of Dena Colovos.)

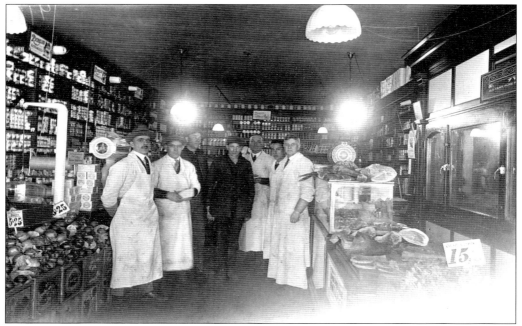

Pictured around 1922, the North Shore Market on Howard Street in Chicago sold groceries and meats, but the butcher shop was rented out. At left, Peter Colovos stands with the figures in aprons, the butchers. (Courtesy of Dena Colovos.)

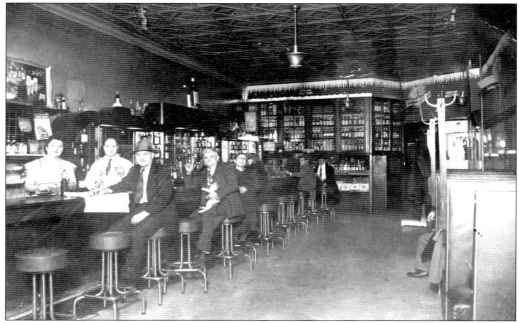

Inside the Newberry Grill at 848 North Clark Street, Sophia and Constantinos Karapanos stand behind the bar around 1950 while Sophia's sister-in-law Marigo and her husband Vasili (holding the cat) sit behind a regular patron known only as Charlie (with newspaper). The store functioned as a tavern and restaurant. (Courtesy of Helen and Thomas Potakis.)

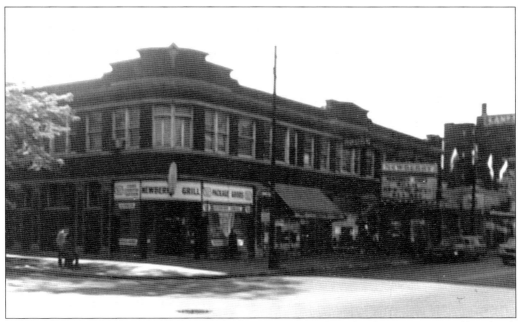

Constantinos and George Karapanos, who arrived with a third brother in 1914 at Ellis Island, settled in Elgin, Illinois, to work in their uncle's candy store. Constantinos and George also worked on the railroads, on the line that became the Empire Builder, eventually quitting the railroads to open the Newberry Grill, seen here in the 1950s. (Courtesy of Helen and Thomas Potakis.)

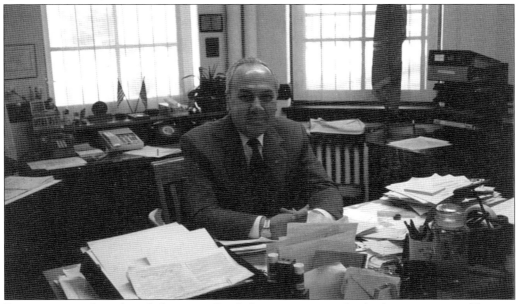

Demonstrating the value of education, Greek Americans rose to leadership positions in Chicago. George L. Mazarakos, serving as principal of Lane Technical High School from 1990 to 1993, is pictured here in his office. Because his father was deceased, Mazarakos very likely received much of his values for education and public service from his uncle Apostolos, a church and political leader. (Courtesy of George L. Mazarakos.)

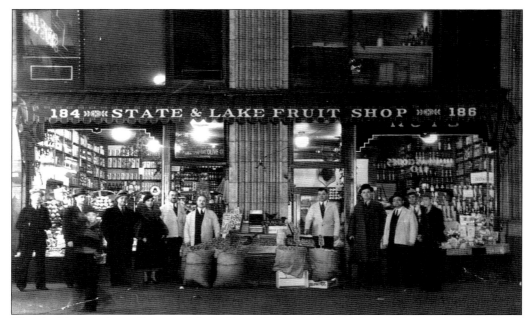

The double-storefront State and Lake Fruit Shop at 184–186 State Street, owned by Spiro Papagianis (second frocked man from left), was a specialty candy and grocery store around 1935. The store also stocked Retsina wine and olive oil, visible on the shelves. Papagianis was famous into the 1950s for the gift fruit baskets he would assemble. (Courtesy of Mary Jo Cally and Katina Mendieta.)

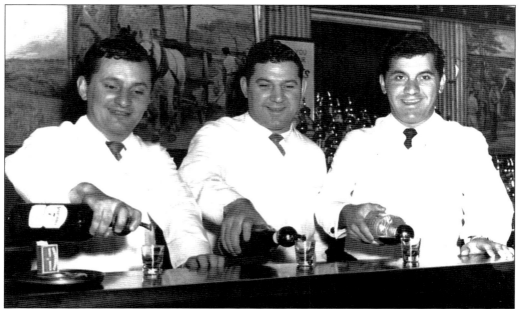

Pictured from left to right in 1950, the Gallios brothers, Nicholas, Peter, and James, demonstrate pouring techniques at Miller's Pub. Originally opened in 1935 and located at 23 East Adams Street, Miller's Pub was a haven for stars of the screen and theater. The brothers were born on Chicago's West Side. (Courtesy of Deborah and Peter Gallios.)

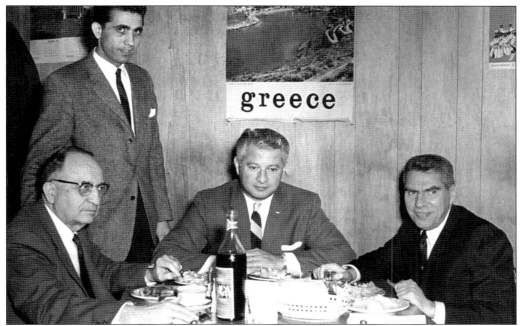

Petros Kogiones (standing) and James Panagakis, Spiro Papas, and Seymour Simon, Cook County commissioner, (seated, from left to right) enjoy a meal at Diana's Grocery and Restaurant at 310 South Halsted Street. Papas owned businesses in Illinois, Indiana, and Washington, and Panagakis was a political supporter of Simon when he was an alderman and later when he was a commissioner, between 1965 and 1970. (Courtesy of Diane and William Rouman.)

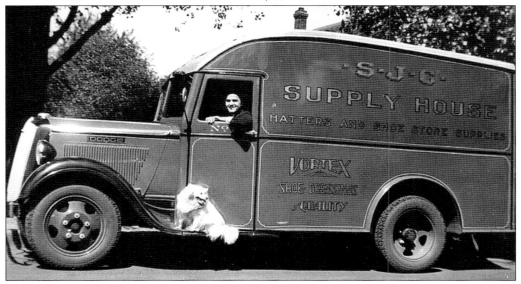

In 1926, Steve J. Colovos began his business out of the basement of his friend's home on the West Side of Chicago, selling shoe findings, heels and soles, leather hatbands, and hats to shoemakers in the Chicago area. He and his truck, seen here in 1936, regularly traveled seven states. In the 1930s, he merged with Manolis Manufacturing but was in business 40 years until entering the restaurant trade in the 1960s. (Courtesy of Terry Mikuzis.)

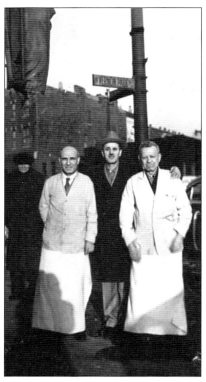

James Lalagos, in apron at left around 1955, owned the Akropolis restaurant near the corner of Blue Island Avenue and Vernon Park. Like Diana's and Hellas Café, the Akropolis was a grocery store in the front and a restaurant in the back. For several years, Hellas Café also featured entertainment including belly dancing. (Courtesy of Maria Karamitsos.)

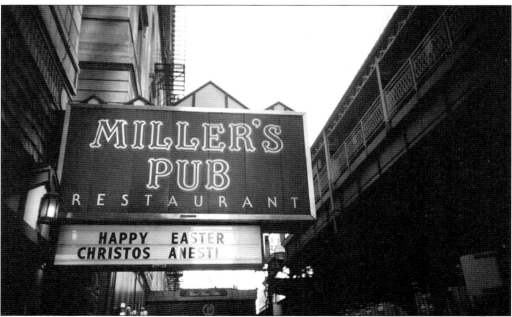

The owners of Miller's Pub, Nicholas, Peter, and James Gallios, proudly display their Greekness by posting "Christos Anesti" on the marquee. For the 40 days following Easter Sunday, Orthodox Greeks typically greet one another with "Christos anesti" (Christ is risen), which is followed in response with "Alithos anesti" (Truly, he is risen). (Courtesy of Deborah and Peter Gallios.)

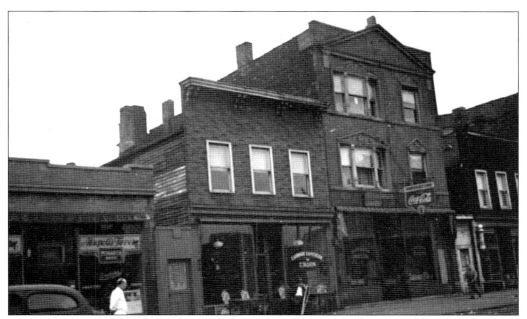

Between Vernon Park and the corner of Harrison and Halsted Streets ran Blue Island Avenue, shown around 1940. Beside the James and Sons Grocery and Akropolis Tavern are the Kafenion Stadion, a barbershop, Becharas coffee distributor, Athenian Candle Store, Hellas Café, Atlas Pharmacy, New Era Cleaners, New Era Restaurant, and the New Era building. As his family grew, James Lalagos demolished walls in the two attached buildings for additional rooms. (Courtesy of Maria Karamitsos.)

A March 13, 1959, restaurant menu, handwritten in Greek, of the Akropolis tavern and restaurant, at 646–648 Blue Island Avenue features dinners such as lamb and rice pilaf (*arni pilafi*) or lamb with macaroni (*arni makaronatha*) for $1.10 and grilled lamb chops (*paithakia scaras*) for $1.75. Part of the "delta" bounded by Halsted, Harrison, and Polk Streets and Blue Island Avenue, this portion of the West Side was demolished in the early 1960s. (Courtesy of Maria Karamitsos.)

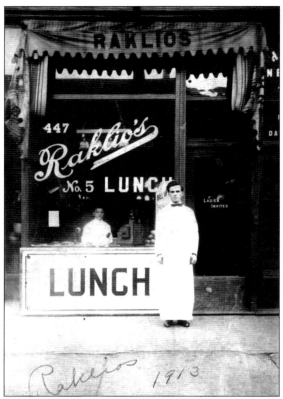

William G. Anastasakis (1891–1947), who arrived from Kastri, Greece, in 1908, was a cook for John Raklios and stands here in front of Raklio's No. 5 in 1913. The restaurant was one of a chain of 45 restaurants operated until the late 1920s when financial hardship and overextension forced the selling off of individual sites. John Raklios was considered one of the most successful of early entrepreneurs. (Courtesy of Bertha Annes Capulos and the Andrew T. Kopan collection.)

The opening of the Athens Hilton (1964) was attended by several dignitaries, including prominent Chicagoan Andrew Fasseas (left) with American ambassador Henry R. Labouisse. Col. Henry Crown, president of Material Service Corporation, Prof. Stratis Andreadis, Conrad Hilton, prime minister of Greece Constantinos Karamanlis, Thomas Pappas, president of Esso Pappas, and San Francisco mayor George Christopher. (Courtesy of Milton and Catherine Fasseas.)

Typical of second-generation Greeks entering the professions, Dr. Lucas C. Politis, pictured here in 1958, was a 1939 Loyola University School of Dentistry graduate. He opened his office in the New Era building in Greektown at Blue Island Avenue and Halsted Street. Drs. Politis, Steve Kakos, and Christopher Costis founded the Hellenic Dental Society in 1963. (Courtesy of the Andrew T. Kopan collection.)

University Restaurant, seen around the 1950s, was a landmark on Harrison Street across from Cook County Hospital, serving the East Side medical community for over 50 years. According to some accounts, it was one of the busiest restaurants in Chicago. The restaurant was owned by the Maggos brothers, standing, from left to right, Nicholas G. Maggos, his son George, and brother Gust. (Courtesy of Alice Maggos Gallios and the Andrew T. Kopan collection.)

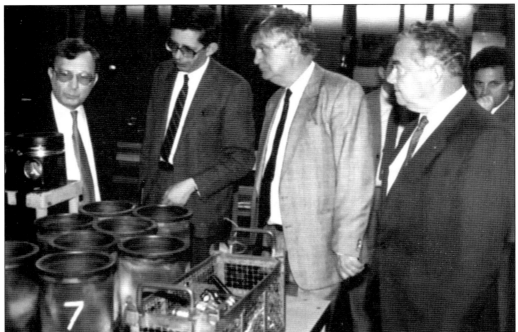

In pursuit of the entrepreneurial spirit, industrialist George D. Aravosis (left), president and chief executive officer of Society of Automotive Engineers International, tours the Fiat research engine laboratory in 1988 in Torino, Italy, with Fiat vice chairman Heinz W. Hahn (third from left). A second-generation Greek, Aravosis demonstrates the rapid socioeconomic rise of Greek Americans. The society establishes and publishes automotive standards worldwide. (Courtesy of the Andrew T. Kopan collection.)

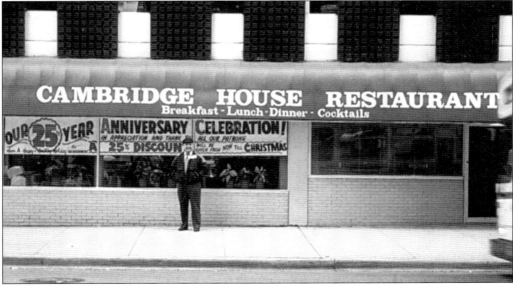

John Maniatis owned the Cambridge House Restaurant (1967–1998) at the corner of Ohio and St. Clair Streets, just west of the heart of the city. The restaurant was a popular coffee shop for journalists, newspeople, and businesspeople in the area. (Courtesy of Denise Maniatis.)

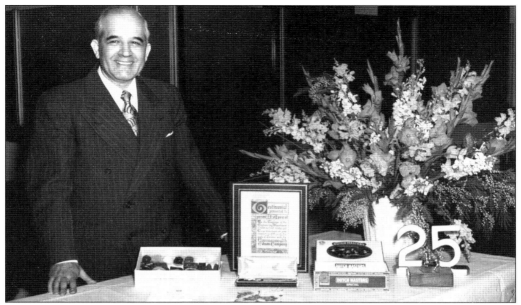

Here in 1950, Speros D. Apostol (1894–1986), born in Vresthena, Greece, was the first man of Greek descent hired as an engineer at the Commonwealth Edison Company. He emigrated in 1912 and completed his education at the Armour Institute of Technology with a bachelor of science degree in electrical engineering in 1922. On leave (1926–1929) during his employment (1922–1959), he was a manager of the commercial department for the Electrical Production Company of Athens. (Courtesy of James Apostol.)

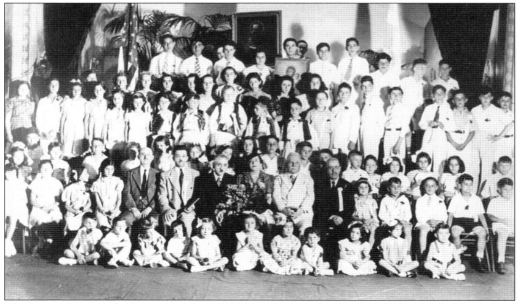

This rare photograph depicts a July 9, 1939, graduation in Herzl Hall in Humboldt Park of Apostolos Pavlos Greek School, one of several independent private schools developed outside the church school system. Organized by the Orthodox Christian Education Society of Chicago, these schools taught Greek language and religion. (Courtesy of the Andrew T. Kopan collection.)

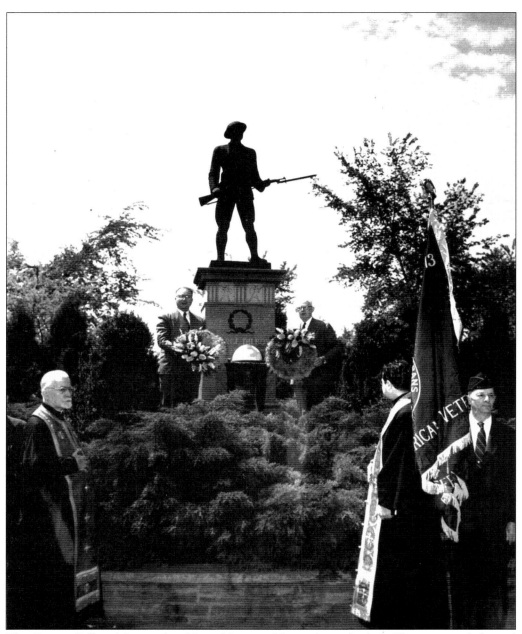

The George Dilboy Memorial at Hines Veterans Hospital in suburban Chicago was dedicated as a memorial to George Dilboy on May 24, 1942. Born in Asia Minor in 1896, he was killed in action in the Battle of Belleau Woods in France in 1918 and was posthumously awarded the Congressional Medal of Honor for bravery, the highest medal of the United States. The priests are Rev. Gabriel Matheopoulos, left, of Assumption Greek Orthodox Church and Rev. Peter Rexinis of St. George Greek Orthodox Church. (Courtesy of the Andrew T. Kopan collection.)

Five
TRADITION AND COMMUNITY

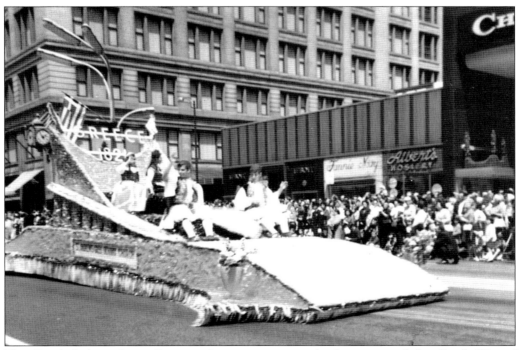

The Greek Independence Day parade commemorates the beginning of the Greek War of Independence that began in 1821, when Greeks in the Peloponnese region of Greece started to overthrow 400 years of Ottoman oppression. This parade float was sponsored by St. Andrew's Greek Orthodox Church in 1967, and at this time, the parade route was down State Street. (Courtesy of Helen and Thomas Potakis.)

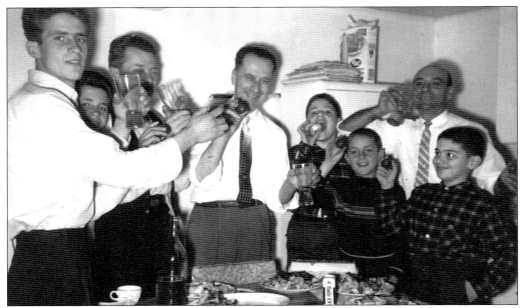

Celebrating Pascha (Easter), three families and two generations are represented in a small Half Day, Illinois, kitchen. From left to right are Angelo and George, sons of Vasilis Davros, George Davros (Vasilis's elder brother) and his son Chris, Kosta (Vasilis's son), Stamatios Grevas, and Michael G. Davros (Vasilis's son). The eggs are traditionally dyed red to symbolize the blood of Christ, and the eggs are cracked together to symbolize Christ's breaking out of the tomb. The winner of the competition cracking captures good luck for the year. (Author's collection.)

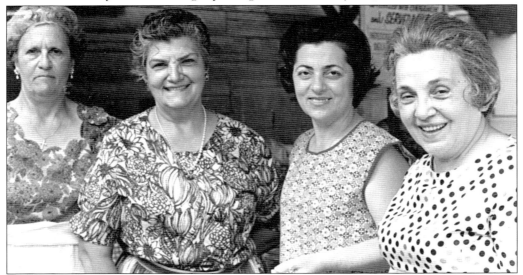

Loukoumades makers, from left to right, Angeline Rapanos, Irene Colovos, Effie Harduval, and Angeline Assimos at St. Andrew's Greek Orthodox Church's annual church festival around 1965 would make the puff pastry dough from scratch and drop it by individual spoonfuls into the hot oil. The tricky art of getting the dough, the oil, the temperatures, the honey, and the cinnamon just right garners affection or disapproval from discerning Greek tastes. (Courtesy of St. Andrew's Greek Orthodox Church.)

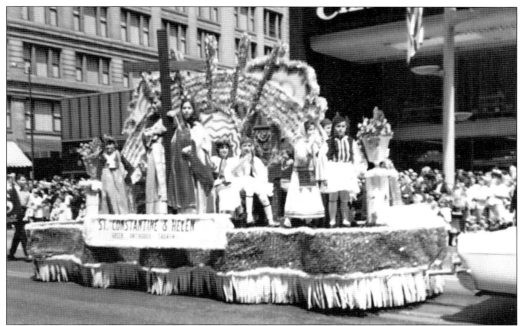

A similar parade float for SS. Constantine and Helen Greek Orthodox Church of Palos Hills in 1967 contains some of the common features of Greek Independence Day celebrations: girls in traditional costume and boys in kilted evzone *foustanelas*. While this parade was on State Street, the current parade route moves south on Halsted Street through the heart of Chicago's Greektown. (Courtesy of Helen and Thomas Potakis.)

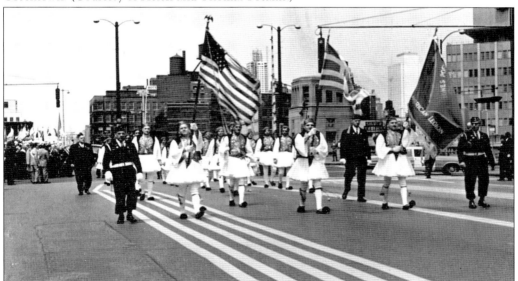

A regular fixture of Greek life is the Greek Independence Day celebration and parade. Dressed in full regalia, the Greek military honor guard of evzones marches down Michigan Avenue in Chicago's downtown in 1965. Remembrances abound and are memorialized in the white kilt, the foustanela, worn by evzones. The kilt has 400 pleats, one for every year of Turkish occupation of the homeland. (Courtesy of the Hellenic Museum and Cultural Center.)

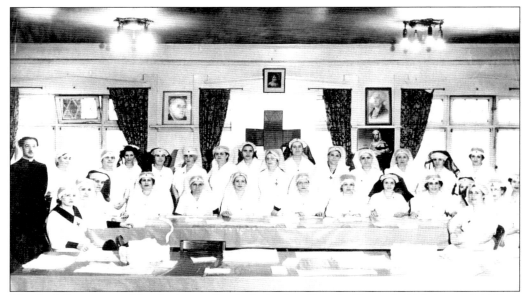

The Red Cross unit of St. Andrew's Greek Orthodox Church Women's Club (around 1940 to 1945) contributed to the war effort. This group was located at the original St. Andrew's church at Winthrop and Hollywood Avenues in Chicago. Rev. Athenagoras Kokkinakis (left) was assigned to St. Andrew's from 1940 to 1945. Later in his career, he was elevated to His Grace, Right Reverend Athenagoras, Bishop of Elias, Western States Diocese. (Courtesy of the Hellenic Museum and Cultural Center.)

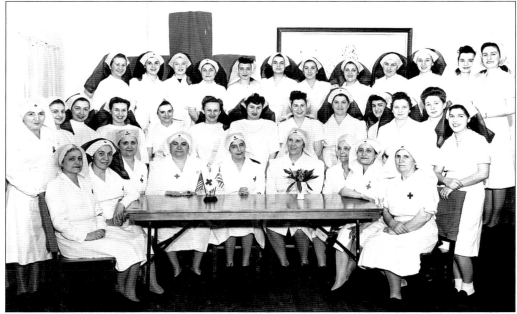

Similar Red Cross units existed at other churches in the Chicago area. This unit was located at St. Demetrios Greek Orthodox Church on Winona Avenue around 1943. The women's club rolled bandages and prepared first aid kits for use on the front lines. (Courtesy of Sophia and Trent Sarantis.)

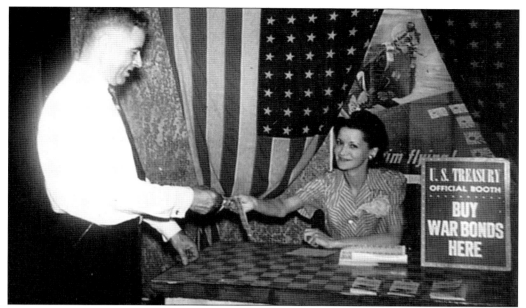

George Mitchell is pictured here, in his Patio Theater during a war bonds drive in 1942. Greek Americans were exceptionally loyal to fighting the totalitarian regimes through enlistment, longer workdays, and devoting a portion of their pay to the purchase of war bonds. One couple, John and Mae Sinadinos, was recognized in 1946 by treasury secretary Frederick M. Vinson for sales of $7,286,000. As well, Mitchell received several citations for outstanding sales. (Courtesy of Margaret E. Boylan.)

César Chávez (right) meets Charles J. Chiakulas of the Industrial Union Department of the AFL-CIO to gain support for a grape boycott to assist California farmworkers around 1965. In 1958, Chiakulas was appointed by Walter Reuther as director of organizing for the AFL-CIO in Greater Chicago. In 1960, he organized and mobilized union support for the presidential candidacy of John F. Kennedy. (Courtesy of James Newport Chiakulas.)

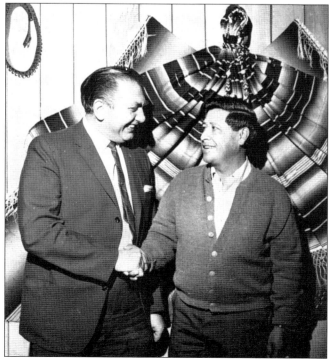

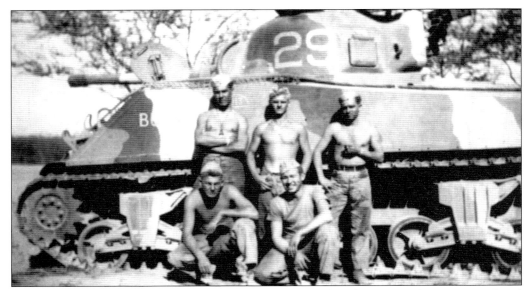

George L. Mazarakos, bow gunner, (left, standing) enlisted in the Marine Corps at age 17 and served in a tank battalion during World War II. Returning from the battles for Kwajalein, Saipan, and Tinian, the crew (shown in 1944) is preparing a new Sherman tank for the invasion of Iwo Jima, which would have been its fourth D-day landing. On the way to Iwo Jima, Mazarakos became ill and was hospitalized on Saipan. (Courtesy of George L. Mazarakos.)

Andrew A. Athens (pictured in 1945) enlisted in the U.S. Army, served from 1942 to 1947, and at the conclusion of World War II, was stationed in Belgium. He became president and chief executive officer of Metron Steel Corporation (1950–1991), the founder and national chair of United Hellenic American Congress (since 1975), the founder and president of hellenicare, the founding president (1995–2006) and honorary president (since 2006) of the World Council of Hellenes Abroad (SAE), and past president and cofounder of International Orthodox Christian Charities. (Courtesy of Andrew A. Athens.)

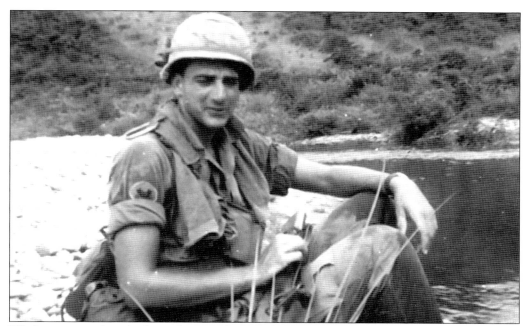

While a corporal with the military police in the 196th Light Infantry Brigade in Chu Lai during the Vietnam conflict, Roy Dolgos (seen in 1967) was decorated with the Bronze Star for meritorious service. Dolgos went on to become director of the Illinois Department of Veterans' Affairs. Dolgos first came to Chicago during the 1964–1965 academic year on a basketball scholarship to Loyola University. (Courtesy of Roy Dolgos.)

The discharge papers (1945) of Peter Gallios show his participation in the campaigns of southern France, the Rhineland, and the European African Middle Eastern theater. During these campaigns, he was awarded two Bronze Stars. He served in Anzio, Italy, was wounded in Salerno, and honorably discharged. (Courtesy of Deborah and Peter Gallios.)

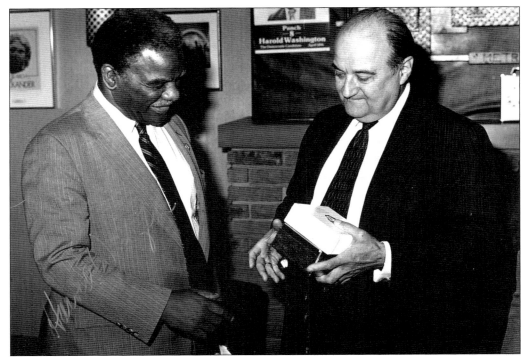

Chicago attorney Constantine N. Kangles, right, is bringing gifts from the Greek community to Mayor Harold Washington, a great supporter of Chicago's Greeks, around 1986. (Courtesy of Helen Angelopoulos and the Andrew T. Kopan collection.)

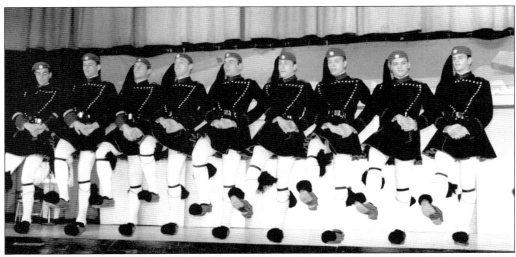

As part of the Lane Technical High School Hellenic Society's illumination of Greek culture, evzones were invited to perform the folk dances of Greece in 1993. Although these are the finest specimens of the Greek military man, as goodwill ambassadors, evzones present the music and dance of Greece and help to keep alive an appreciation of the culture and ideals of Greece. (Courtesy of George L. Mazarakos.)

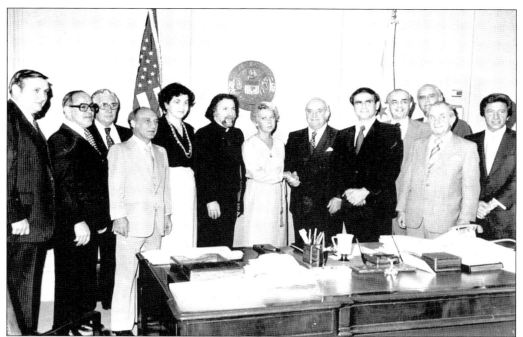

Chicago mayor Jane Byrne (center) meets James Peponis, Michael Svourakis, Nicholas Melas, Beatrice Marks, Chancellor Isaiah, Andrew A. Athens, Chris Karafotias, and Ted Pappas in the mayor's chambers in celebration of Greek contributions to Chicago in the 1980s. (Courtesy of Andrew A. Athens.)

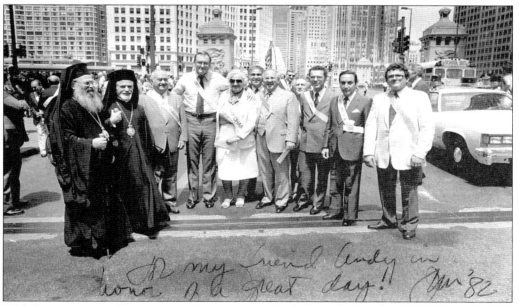

With his arms around honorary cochairs Andrew A. Athens (left) and state senator Adeline J. Geo-Karis, Illinois governor Jim Thompson celebrates the start of the Greek Independence Day parade in 1982. Among other dignitaries are His Grace Bishop Iakovos, head of the Chicago diocese of the Greek Orthodox Church, to the left of Athens. (Courtesy of Andrew A. Athens.)

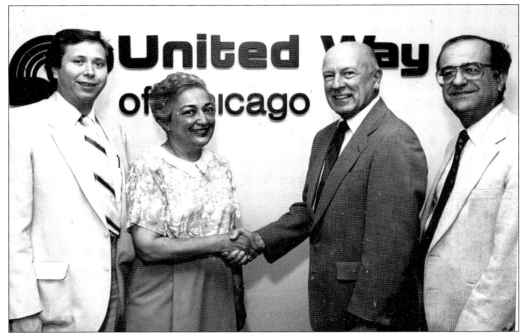

Around 1980, Ethel Kotsovos receives the first significant grant from the United Way and People's Gas. The United Way had never funded a Greek organization before, so the grant enabled Greek American Community Services (GACS) to hire a social worker and provide services to seniors. (Courtesy of John Psiharis.)

Greek American Rehabilitation and Care Center (pictured in 2007) in Wheeling became a reality after years of struggle through the efforts of many people in the Greek American community. GACS was the final organization that provided the means to establish the institution. (Author's collection.)

Philanthropy at the most basic level serves as one of the cornerstones of the Greek ethos. In April 1955, "Danny Boy" Terzakis hosted a gathering at his Shell station at 10659 South Western Avenue to assemble donations for a Toys for Tots campaign. Among all the Shell gasoline stations in the country, Terzakis gathered the most truckloads in donations for the Marine Corps. (Courtesy of George D. Terzakis and the Andrew T. Kopan collection.)

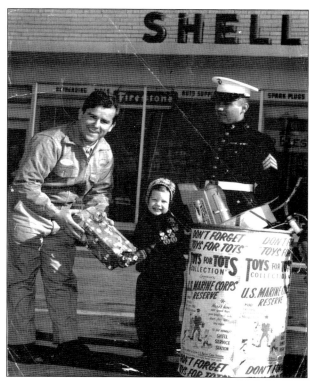

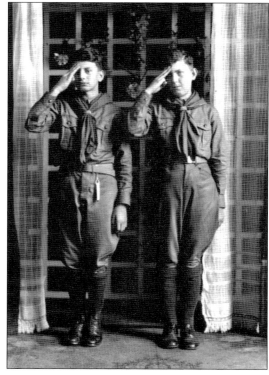

The Chicago immigrant community developed both formal and informal structures—fraternal lodges, social and athletic groups, and mutual benevolent societies. In 1937, Michael Petrakis (left) and Ted Theodore belonged to the South Side SS. Constantine and Helen Greek Orthodox Church, which sponsored their American Boy Scout troop. (Courtesy of the Andrew T. Kopan collection.)

63

Sen. Barak Obama and Roy Dolgos (right) visit at a town hall meeting in 2006 during one of Obama's trips to Springfield. Dolgos, director of the Illinois Department of Veterans' Affairs, was a Vietnam veteran. The senator came to the meeting to educate himself on veterans' issues. (Courtesy of Roy Dolgos.)

Chicago mayor Richard J. Daley is presented in the late 1980s with gigantic Greek-made worry beads (*komboloi*) at one of the many Hellenic cultural events sponsored by the metropolitan Greek community. The origin of worry beads is speculatively pre-Christian, Turkish, or a representation of the Roman Catholic rosary. (Courtesy of the Greek Press and the Andrew T. Kopan collection.)

Convening in 1964, the executive committee of the board of directors of the Hellenic Foundation discusses plans for Hollywood House, a retirement home at 5700 North Sheridan Road. Pictured are, from left to right, (first row) Alec K. Gianaras, president and major benefactor; Rev. George Mastrantonis of St. Andrew's Greek Orthodox Church; and Peter D. Gianukas, treasurer; (second row) Chris G. Kalogeras, vice president; Georgia Anton, president of the women's auxiliary; Peter Adinamis, vice president; and Themi Vasils, secretary. (Courtesy of the Andrew T. Kopan collection.)

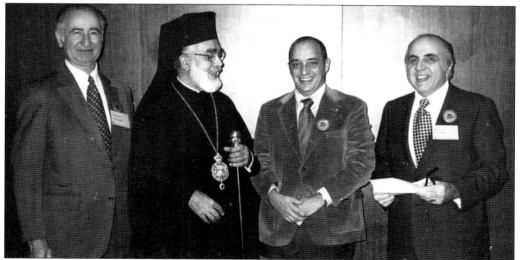

Celebrating a three-day bicentennial symposium in 1976 at the University of Chicago, members of the organizing committee, from left to right, cochair and University of Illinois at Chicago professor Alexander Karanikas, program chair and Northwestern University professor Charles Moskos, and cochair and DePaul University professor Andrew T. Kopan visit with then archbishop of North and South America Iakovos during a dinner to honor him and Greek ambassador Menelaos Alexandrakis. (Courtesy of the Andrew T. Kopan collection.)

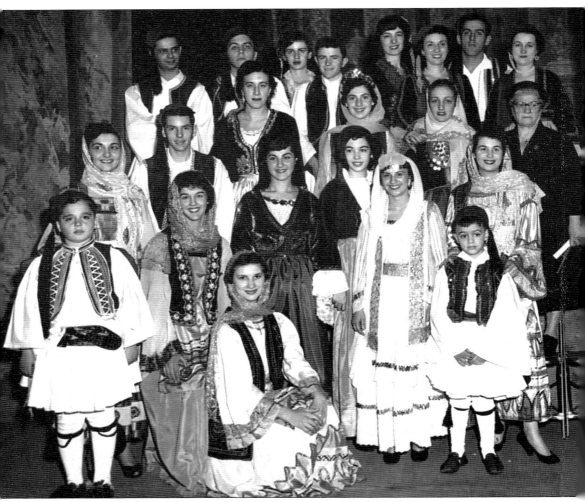

Presbytera Petrakis's dance troupe, in full regalia around 1950, had no official name but was organized by her on the South Side and performed in Chicago. Petrakis (third row, far right) was the wife of Rev. Mark (Marcos) Petrakis, pastor of SS. Constantine and Helen Greek Orthodox Church, and she was the mother of famed author Harry Mark Petrakis. (Courtesy of Maria Karamitsos.)

Six

THE CHURCHES

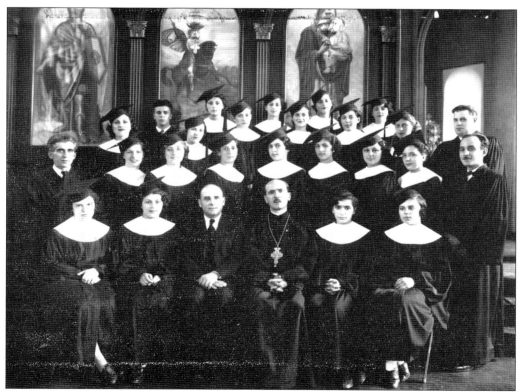

The choir of a Greek Orthodox church served a valuable function in the life of the Sunday liturgy by carrying on the rich tradition of hymnology. Here at St. Demetrios Greek Orthodox Church around 1930, a choir composed mostly of young women poses for a formal photograph. (Author's collection.)

Greek schools and mutual aid societies were established by Rev. Theodore Prussianos, an early Greek Orthodox priest in Chicago. This rare line drawing of Prussianos notes that he was active in Chicago between 1909 to 1915 and 1917 to 1921. (Courtesy of the Andrew T. Kopan collection.)

A pioneer priest serving Greek Orthodox churches in Chicago, Rev. Ambrose Mandilaris was known as an "empire builder" because of his aggressiveness in founding churches. He served Holy Trinity and SS. Constantine and Helen Greek Orthodox Churches in the early 20th century. (Courtesy of the Andrew T. Kopan collection.)

Rev. Demetrios Koursaris (right), assisted by Chanter Andrew Adam, performs a baptism around 1960 at St. Andrew's Greek Orthodox Church. Orthodox Christians believe that the sacrament of baptism, full immersion into water, conducted by a priest except in extreme emergency is a burial and resurrection with Christ. The second part of baptism is chrismation in which the recipient is marked with the seal of the Holy Spirit. Chrismation prepares the recipient for communion. Baptism and chrismation are the sacraments for entry into the life of the Orthodox Church. (Courtesy of Helen and Tom Potakis.)

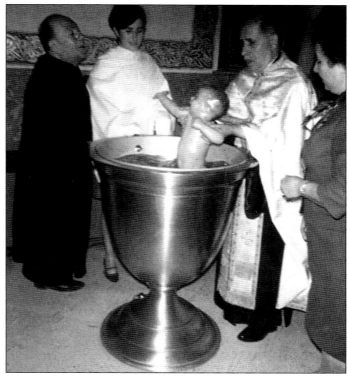

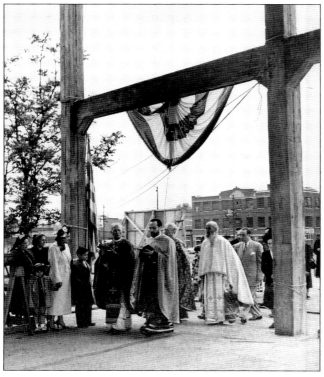

In 1948, the clergy enter the site that would become SS. Constantine and Helen Greek Orthodox Church on Seventy-fourth Street and Stony Island Boulevard to perform an *agiasmos* service, a blessing performed with holy water. The parish voted in 1909 to establish the first location at Sixty-first Street and Michigan Avenue. The church at its current location in suburban Palos Hills was completed in 1976. (Courtesy of the Hellenic Museum and Cultural Center.)

The old St. Andrew's church at the corner of Hollywood and Winthrop Avenues on the city's North Side was founded by "builder-priest" Fr. Constantine Hadji-demetriou (1926–1930) and the first parish council president, Paul Demos. Rev. Irenaos Tsourounakis (1930–1937) guided the parish through the tough times of the Depression and was succeeded by Rev. Athenagoras Kokkinakis (1940–1945), who was elevated to bishop in 1945. (Courtesy of Katherine G. Siavelis.)

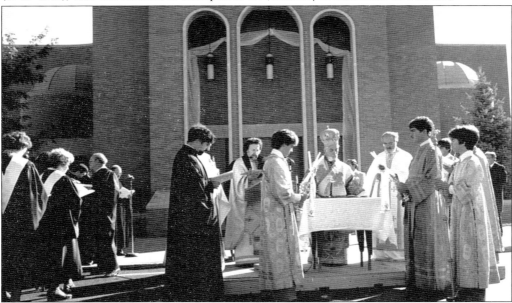

The consecration service for St. John the Baptist Greek Orthodox Church in Des Plaines in 1979 is being performed by His Grace Bishop Iakovos (center), Chancellor Isaiah, at left beneath center arch, and Rev. Manousos Lionikis, to His Grace Bishop Iakovos's left. Since this picture was taken, Chancellor Isaiah has been elevated to His Eminence Metropolitan Isaiah of Denver and His Grace Bishop Iakovos has been elevated to His Eminence Metropolitan Iakovos of Chicago. (Courtesy of Harold and Faye Peponis.)

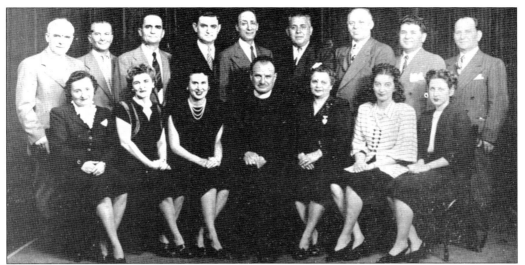

The third annual convention committee of the Federation of Sterea Hellas with supreme president Rev. Daniel Gambrilles, seated at center around the 1950s, was a philanthropic and social organization devoted to maintaining Hellenic heritage and values. Still in existence, the organization provides financial support for scholarships, philanthropy, Greek schools, and university chairs in modern Greek studies. (Courtesy of Harold and Faye Peponis.)

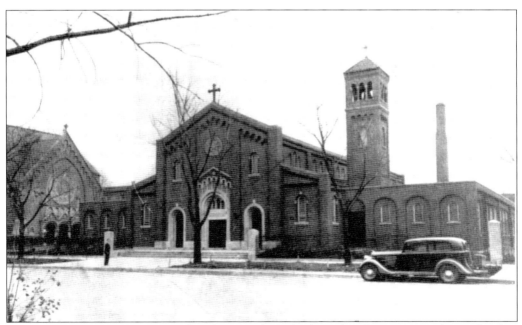

The former SS. Constantine and Helen Greek Orthodox Church, constructed in a basilica style, was located at 6105 South Michigan Avenue. Established in 1909, the first church was constructed in 1910 but was destroyed by fire on Holy Monday in 1926. In 1948, the church moved to Seventy-fourth Street and Stony Island Avenue in the South Shore. The property was sold in 1972 and a Byzantine-style church was erected in suburban Palos Hills in 1976. (Courtesy of the Andrew T. Kopan collection.)

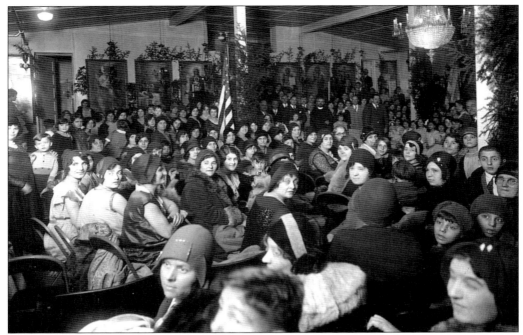

A 1928 photograph of the interior of the old Assumption Greek Orthodox Church, built in 1925, depicts a graduation from the church's Plato School, on the city's West Side. An unusual seating arrangement, facing to the side of the altar rather than at the icon screen (iconostasion) shows respect for the altar. The priest and first pastor (center), Fr. George Papanikolaou, served as the teacher for the upper grades. (Courtesy of Nicholas G. Manos and the Andrew T. Kopan collection.)

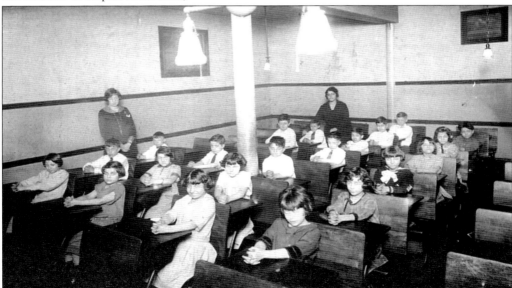

Charged with education in both Greek and English at Koraes Greek American School of SS. Constantine and Helen Greek Orthodox Church, this c. 1925 fourth-grade class is led by teachers Mrs. Simms and Alexandra Tanga. (Courtesy of the Hellenic Museum and Cultural Center.)

SS. Constantine and Helen's first-grade class of 1965 at Koraes Greek American School, looking very different from its 1925 counterpart, still shared many of the same values except that in the struggle for survival of Greek culture and language in America, the work of Greek schools and their principals and teachers is magnified by increasing distractions from the larger culture. (Courtesy of Emmanuel Andrew Bennett.)

This picture (around 1920–1930) of Socrates Greek School of Holy Trinity Greek Orthodox Church in Chicago shows a rudimentary map of Greece on the left side of the chalkboard. It is likely that the photograph was taken around Christmastime because the board at right reads, in translation, "The Birth of Christ / Glory to God in the highest / and on earth peace to men." Clearly geography and theology were parts of the curriculum. (Courtesy of the Hellenic Museum and Cultural Center.)

The parish council (*symboulion*) of Annunciation Cathedral and St. Demetrios Greek Orthodox Church (in 1939) governed the affairs of the United Churches through the difficult times ending the Great Depression. After averting financial difficulties, the relationship between the two parishes was formally dissolved in 1983. (Courtesy of Harold and Faye Peponis.)

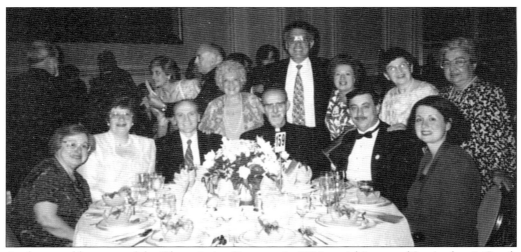

At the grand banquet of the Clergy Laity Congress in 1994, parishioners of St. Andrew's Greek Orthodox Church gather to celebrate the conclusion of the conference. Pictured are, from left to right, (first row) Evangeline Mistaras, Evangeline and Thomas Dallas, Fr. John Kutulas, and Angelo and Olga Leventis; (second row) Mary Trigourea, Fred Chapekis, Bessie Trigourea, Frances Tsaoussis, and Koula Diamantis. (Courtesy of St. Andrew's Greek Orthodox Church.)

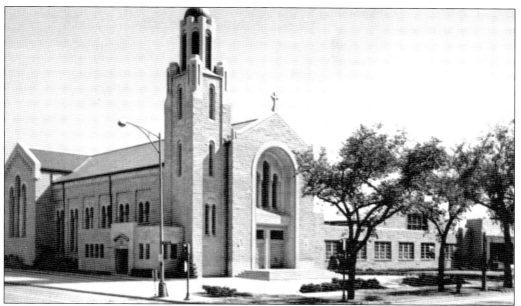

Since its construction in 1956, St. Andrew's Greek Orthodox Church has marked the intersection of Sheridan Road, Hollywood Avenue, and Lake Shore Drive and has been the home to several dynamic clergy leaders: Fr. John Hondras, Fr. John Kutulas, and Fr. John Kalomas. One community outreach activity stems from an earlier association with dynamic clergyman Rev. George Mastrantonis, who spearheaded the development of Hollywood House, the senior residence building across the street. (Courtesy of St. Andrew's Greek Orthodox Church.)

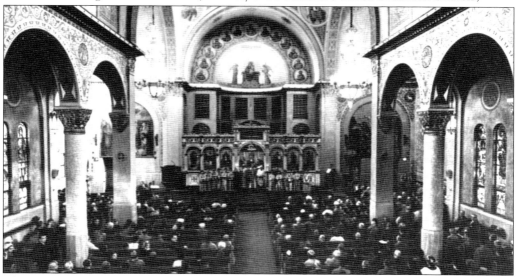

The current Assumption Greek Orthodox Church at Harrison Street and Central Avenue replaced a wooden structure in 1937. At one time, the parish was the largest in the United States, operated robust day and afternoon schools, and swelled to a Sunday school enrollment of 2,200 students with 90 faculty members. Seen here around 1950 from the interior, the architecture is considered one of the best examples of neo-Byzantine architecture in Chicago. It was restored in 2000 to even greater splendor and style. (Courtesy of the Andrew T. Kopan collection.)

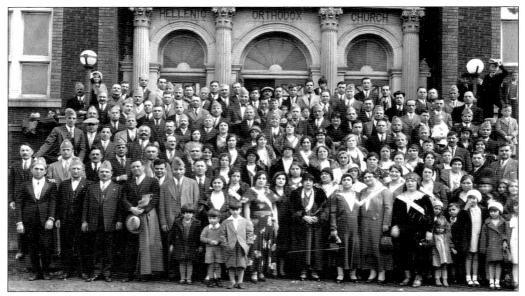

Similar in appearance to today's Annunciation Cathedral in Chicago and the Hellenic Orthodox Church in Gary, Indiana, SS. Constantine and Helen Greek Orthodox Church (pictured around 1930) was established to ease the burden of going to Chicago for rites of the Orthodox Church. Originally named St. Constantine, the name of Helen was added in 1917. A men's fraternal organization is at the left, and on the right are members of the Greek American Progressive Association (GAPA). (Courtesy of Irene Kaporis.)

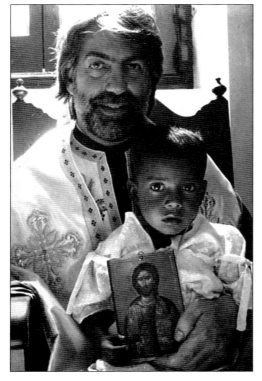

His Eminence Metropolitan Nikitas of Hong Kong and Southeast Asia (during Pascha 2002) served as the parish priest of St. Demetrios Greek Orthodox Church from 1995 to 1996 and was elevated to his position in 1996. In 2007, he was appointed dean of Patriarch Athenagoras Orthodox Institute in Berkeley, California. (Courtesy of Irene Kaporis.)

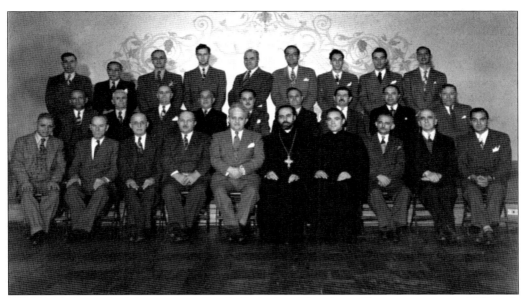

The parish council of Assumption Greek Orthodox Church in Chicago is seen in 1953 with the first American-born parish priest at Assumption, Fr. Peter Bithos (1944–1953), in the center. Fr. George Mastrantonis, known for his activities in starting retirement home Hollywood House as well as his OLOGOS (Orthodox Lore of the Gospel of Our Savior) pamphlets, is seated to his right. (Courtesy of Diane and William Rouman.)

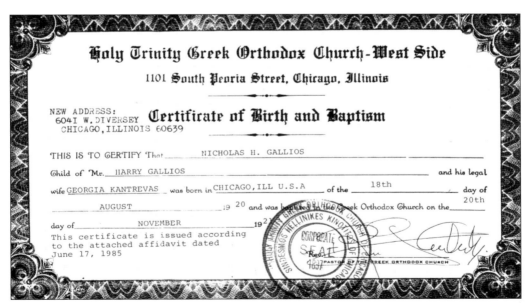

A certificate of birth and baptism shows that Nicholas Gallios was born on August 20, 1920, and baptized on November 20, 1921. The official corporate seal for Holy Trinity Greek Orthodox Church bears the date 1897, and the certificate shows the address of the old church in Greektown. (Courtesy of Deborah and Peter Gallios.)

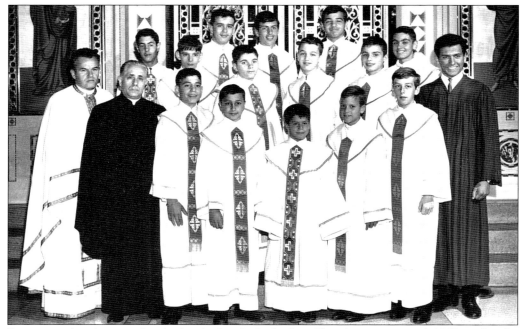

For many altar boys at St. Andrew's Greek Orthodox Church, seen around 1960 under the direction of Fr. John Hondras (left), lasting relationships formed as a result of their participation in services. Often, at the anniversaries of clergy, former altar boys return to serve. (Courtesy of Lily Pagratis Venson.)

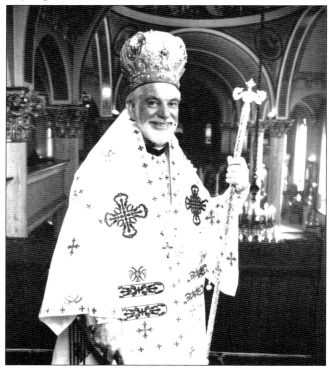

In 1983, Annunciation Church was designated the cathedral of the Archdiocese of Chicago. After Ecumenical Patriarch Bartholomew in Constantinople realigned the dioceses of the United States into metropolitanates, His Grace Bishop Iakovos (now Metropolitan), seen around 2000 on LaSalle Street, ministers to the faithful not only at the cathedral but to the six-state region under his direct authority, including Illinois, Wisconsin, Indiana, Iowa, Minnesota, and Missouri. (Courtesy of James Michael Mezilson.)

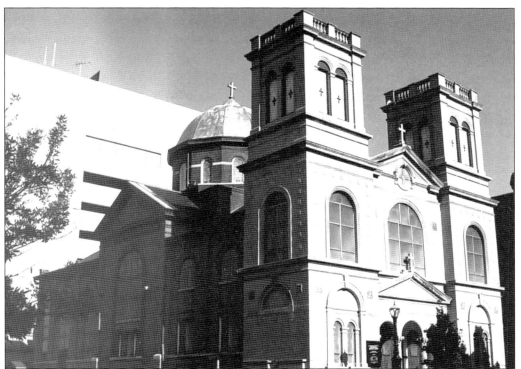

Pictured in 2007, Annunciation Cathedral, the first Greek Orthodox community in Chicago, was organized in 1892 when the Lycurgus Society requested a priest from the synod of bishops of the Church of Greece. The current structure on LaSalle Street was erected in 1910. (Author's collection.)

Established in 1923, St. George Greek Orthodox Church was founded in response to divided political loyalties between supporters of Eleftherios Venizelos and King Constantine I in the homeland. Supporters of the king, founded, purchased, and adapted a Lutheran church for Orthodox worship. This building still serves the parish. (Author's collection.)

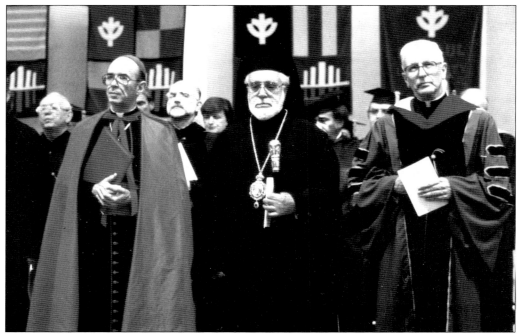

In 1984, from left to right, Roman Catholic Archbishop Cardinal Joseph Bernardin, His Eminence Archbishop Iakovos of North and South America, and Fr. John T. Richardson, president of DePaul University, are together onstage at the presentation of an honorary doctor of humane letters to the Greek Orthodox archbishop. (Courtesy of the Andrew T. Kopan collection.)

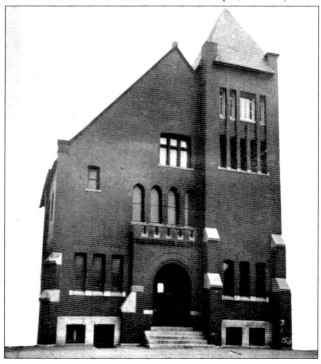

Holy Trinity, established in 1897 south of Greektown at 1101 South Peoria Street, was the first permanent Greek Orthodox church in Chicago. The church served the needs of immigrant and later generations of parishioners until the structure was demolished in the early 1960s to provide space for the nascent University of Illinois at Chicago campus. Much of today's campus occupies the neighborhood space of the former Greektown. (Courtesy of the Andrew T. Kopan collection.)

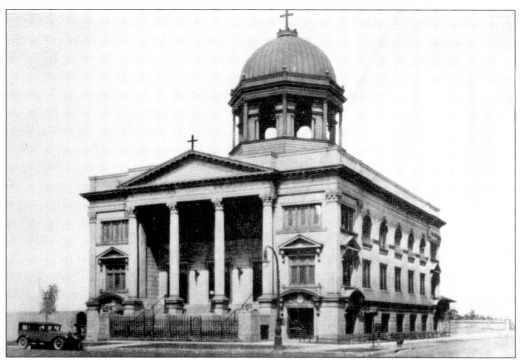

St. Basil Greek Orthodox Church, founded in 1923 in the former Jewish synagogue, Anshe Shalom Temple, has served the West Side and was designated as the First Greek Orthodox Catherdral of Chicago from 1923 to 1930 by Bishop Philaretos. Its central location at Ashland Avenue and Polk Street provided an ideal location for many events, such as the Orthodox Youth Organization of Chicago (OY), initiated in 1946. (Courtesy of the Andrew T. Kopan collection.)

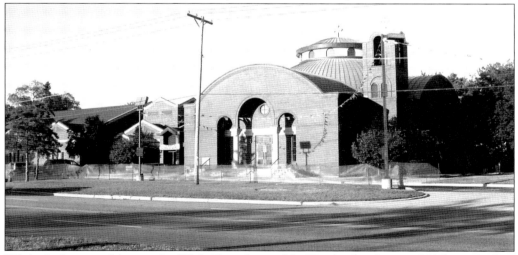

While the history of the parish of Holy Taxiarhai and St. Haralambos (seen in 2007) in suburban Niles dates back to 1951 to the northwest side and the Humboldt Park area of Chicago, the church struggled to survive until the current building was completed in 1988. The interior of the church is beautifully adorned with an icon screen of African mahogany, an ornate chandelier, and meticulous attention to the iconography. (Author's collection.)

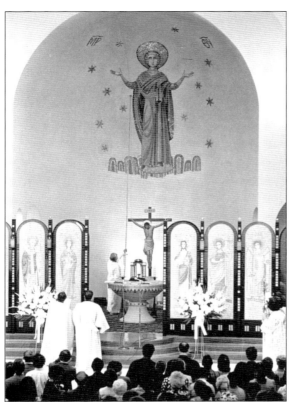

The consecration of St. Nicholas Greek Orthodox Church in south suburban Oak Lawn and the sanctification of the icons with holy myrrh by the late Archbishop Iakovos were some of the highlights of the 1974 Clergy Laity Congress in Chicago. The church was formerly located in Chicago's west Englewood neighborhood. (Courtesy of the Andrew T. Kopan collection.)

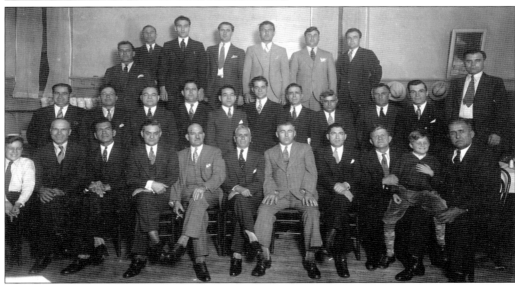

As immigrants settled in the United States, efforts to preserve culture met with the desire to associate and socialize together. Like the AHEPA, which was formed later in Atlanta and spread nationally, the local St. Constantine Men's Society provided opportunity for recreation and camaraderie. In this photograph, cousins and brothers define the social network that would later expand into families. (Author's collection.)

Seven
SOCIAL AND FRATERNAL ORGANIZATIONS

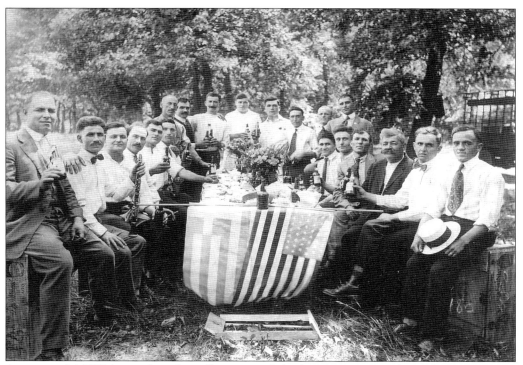

A group of AHEPA members formally pose and display American and Greek flags, musical instruments, and potables during a picnic around 1926. Although not always the largest organization of Greek Americans, the AHEPA has created a network of support, including retirement homes and scholarships. (Courtesy of the Hellenic Museum and Cultural Center.)

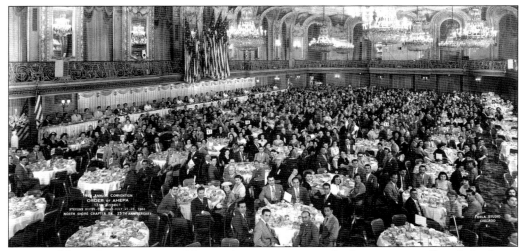

Post–World War II conventions of fraternal organizations reached proportions of lavish display as proof of socioeconomic ascendancy as this photograph of a 1951 order of the AHEPA convention suggests. Held at the Stevens Hotel, now the Conrad Hilton, on Michigan Avenue from July 21 to 23, the 19th annual convention marks the 25th anniversary of the founding of Northshore chapter No. 94. (Courtesy of the Hellenic Museum and Cultural Center.)

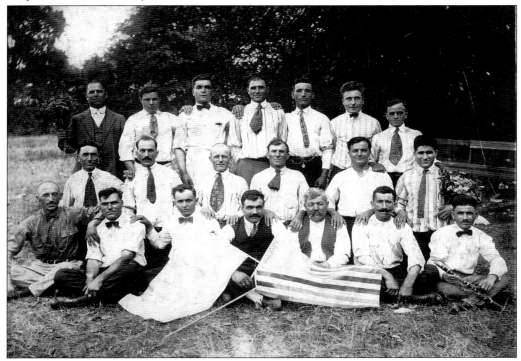

Founded in Atlanta on July 26, 1922, the AHEPA was originally a protective organization to combat racism against Greeks in the South. An additional benefit of the fraternal organizations was the provision of burial insurance. Greek Americans wanted to prove to relatives in the homeland that Greeks received Orthodox burials in the United States. (Courtesy of the Hellenic Museum and Cultural Center.)

This portrait depicts Rev. Fr. George Mastrantonis (1906–1988), founder of the Greek Orthodox Welfare Foundation, which later became the Hellenic Foundation. His efforts were dedicated to educating the Greek community on the need for providing housing, home care, and social and foster services for the elderly, needy, and orphans. In 1973, the Hellenic Foundation purchased Hollywood House at 5700 North Sheridan Road as a retirement residence. (Courtesy of the Andrew T. Kopan collection.)

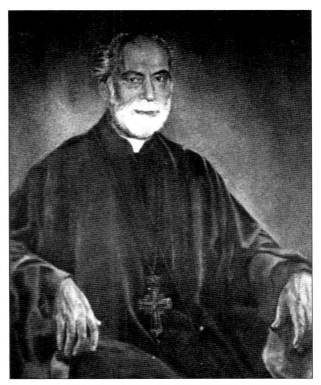

The Pan-Arcadian Federation with supreme president Harold A. Peponis presents a charter to a newly formed chapter in the Chicago metropolitan area. (Courtesy of Harold and Faye Peponis.)

As Lane Technical High School celebrated its 85th anniversary in 1993, the school's Hellenic Society and history department sponsored a cultural program that featured the dancing of the evzones, the Greek presidential honor guard and an elite unit of the Greek army. The evzones have presented traditional Greek dance and music around the world before royalty and heads of state. The evzones are led by Lt. Col. Harry Samaras and Capt. Stelios Tripolitakis. (Courtesy of George L. Mazarakos.)

Not to be outdone by the North Side Hellenic Republican Club, chartered on October 29, 1925, the South Side Hellenic Republican Club also functioned to support political candidates, which demonstrates the early involvement of Greeks in the political life of the city. (Courtesy of George Sinadinos.)

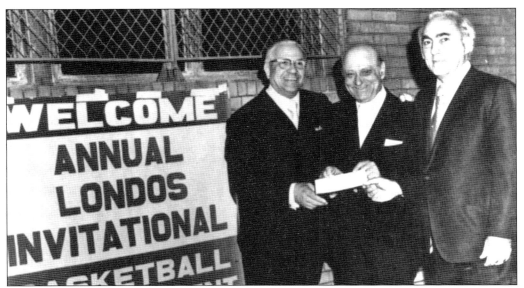

Although founded in 1931, the National Hellenic Invitational Basketball Tournament (NHIBT) was for a time known as the annual Londos Invitational Basketball Tournament in honor of Jim Londos (born Chris Theophelos). From left to right are Alec Gianaras, Peter Gianukos, and James J. Kulidas, enthusiastic and longtime supporters of the tournament and the ideals upon which it was founded and continues. Jim Londos, a venerated name among Hellenes who understand athletics, was a world champion professional heavyweight wrestler. (Courtesy of Phil Bouzeos.)

Participants in the NHIBT have had leadership role models in, from left to right, Anthony Loukas, Phil Bouzeos, George Loukas, and Angelo Loukas, pictured in 2005. The three Loukas brothers were captains of their college football teams and have all been inducted into the NHIBT Hall of Fame while the Bouzeos family has provided dedication and perseverance for over a half century. (Courtesy of Phil Bouzeos.)

Philanthropist Esther Petrakis Christopher wears the uniform of the GAPA at a 1936 event at the old Auditorium Theater at Congress Parkway and Wabash Avenue. Founded in 1923 in Pittsburgh, the GAPA sought to preserve Greek culture and language and is considered a more conservative organization than the AHEPA. In 1936, Chicagoan Andrew Margaritis served as the supreme president. (Courtesy of Esther Petrakis Christopher and the Andrew T. Kopan collection.)

An AHEPA certificate of merit was conferred on Theodore Vlahandreas on April 10, 1940, by the supreme lodge not only "in appreciation of his manly qualities" but actually for participation in fund-raising activities. The certificate is signed by supreme president V. I. Chebithes. Theodore Vlahandreas came to America in 1893 and operated a restaurant at 806 West Madison Street. (Courtesy of Diane and William Rouman.)

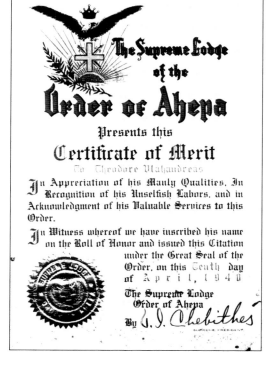

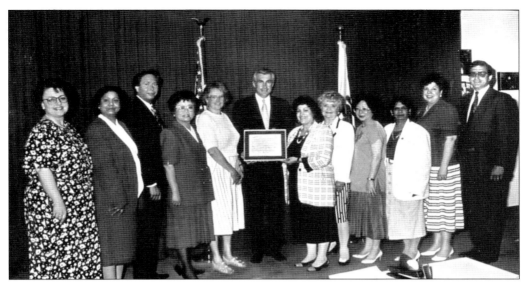

With Gov. Jim Edgar (center, with plaque), the board members of a multiethnic coalition of representatives of community groups, the Coalition for Limited English Speaking Elderly (CLESE), including GACS, successfully lobbied to serve limited and non-English-speaking elderly, thus helping to channel money to organizations that specifically benefitted ethnic providers. The founder of the federal model program, the CLESE, John Psiharis is third from the left. (Courtesy of John Psiharis.)

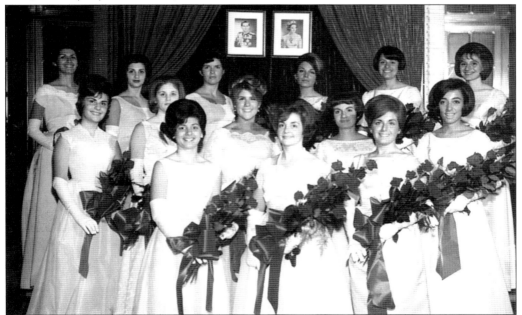

The first "celestial soiree" and debutante cotillion of May 23, 1965, was attended by more than 1,000 guests at the Conrad Hilton Hotel. The organizing committee was chaired by Mrs. Sam Tzakis, who initiated the project. Among the many congratulatory messages were from Pierre DeMets, president of SS. Constantine and Helen Greek Orthodox Church, then located at 7351 Stony Island Avenue. (Courtesy of Dimitria Tzakis and the Andrew T. Kopan collection.)

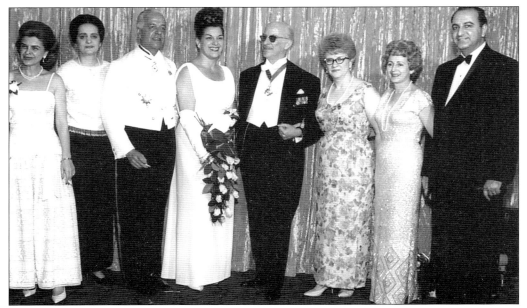

The first Hellenic debutante cotillion premiered in 1965 and was attended by several dignitaries, including, from left to right, Mrs. Tsoussis; Tessie Alexander; Alexander Matsas, the Greek ambassador to the United States; Dimitria "Dee" Tzakis, chair of the organizing committee; Mr. Tsoussis, consul general of Greece; Maria Manus; Thula DeMets; and Sam Tzakis. It was known as the St. Helen Cotillion, continued for 30 years, and in 1998 was revived and renamed Hellenic League Debutante Cotillion. (Courtesy of the Andrew T. Kopan collection.)

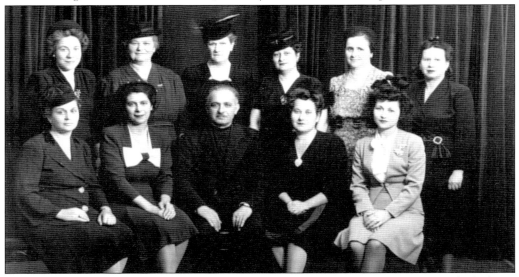

The Philoptochos Society (friends of the poor) chapter of the Annunciation Cathedral was charged with the responsibility of offering assistance to those in need in the parish. Pictured around the 1940s are, from left to right, (first row) Katina Secaras, Mary Brotsos, Rev. Nikitas Kesses, Helen A. Mantis, president, and Vaso Dangard; (second row) Angeline Corinthos, unidentified, Katherine Nicolopoulos, Smaragda Broolis, Mrs. Coorlas, and Julia Fasseas. (Courtesy of Bertha Annes Capulos and the Andrew T. Kopan collection.)

Greek Orthodox Youth of America (GOYA) was officially founded in Chicago in July 1951 for youths 18 to 35 years of age. The group was organized under the host institution the Orthodox Youth Organization of Chicago. GOYA at its peak was comprised of some 32,000 members in 250 parish chapters. The GOYAN magazine was published on a quarterly basis for a period of 10 years in Chicago and had an international circulation of 33,500. (Courtesy of the Andrew T. Kopan collection.)

A. Steve "Stash" Betzelos, seen around 2006, is a tireless member of the AHEPA and has been a visible leader on a national scale as supreme governor and supreme president of the order. This fraternal organization in the Greek community has served to Americanize Greek immigrants during the early days of immigration and in recent years has reconsidered its mission as one to preserve the ideals of Hellenism. (Courtesy of A. Steve "Stash" Betzelos and the Andrew T. Kopan collection.)

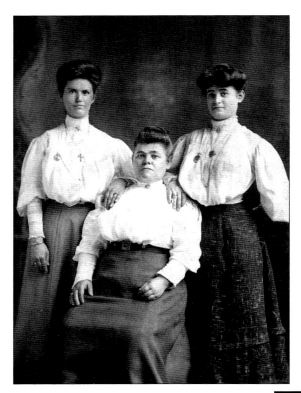

The Sikokis sisters, Venetta (left) and Peloponnesia, pose around 1905 with their mother. Venetta is the grandmother of former gubernatorial candidate, president of Triton College, and state superintendent of education Michael Bakalis. (Courtesy of Diane and William Rouman.)

In 1930, Steve Chapin (Stavros Chipianitis) established *The Greek Radio Hour*, the first Greek radio program in Illinois. Chapin was born in Tripolis, Greece, in 1889 and arrived in the United States in 1901. He attended Chicago public schools and married Mable Kretchmer, here at his side, in 1911. (Courtesy of the Andrew T. Kopan collection.)

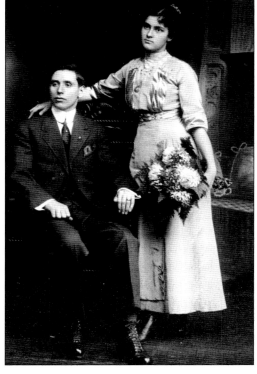

Eight
ARTS, CULTURE, AND RECREATION

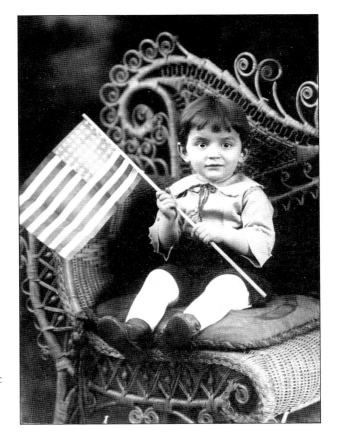

James Michael Mezilson (born in 1919) became a political activist and assistant to the late U.S. senator Paul Douglas. As a Chicago journalist for 60 years, Mezilson served the Greek American community writing a weekly column for the Chicago press. Having been recognized as the "dean" of Greek American correspondents in America, Mezilson helped found the Hellenic Museum and Cultural Center. (Courtesy of the Andrew T. Kopan collection.)

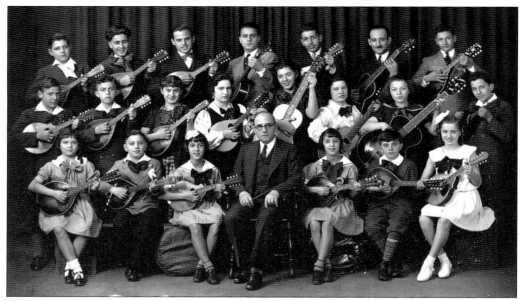

For many immigrant parents, preserving the roots of their culture is important. Various levels of schoolchildren and adults were educated to play stringed instruments. During the 1930s, even in the midst of the Great Depression, children were provided the opportunity for instruction in the mandolin, an eight-string instrument little used today, and in the more traditional six-string guitar. (Author's collection.)

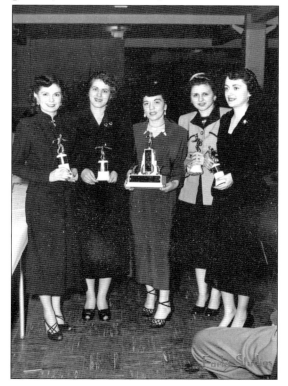

AHEPA Northshore chapter No. 94 boasted a women's auxiliary, the Daughters of Penelope, Danae Chapter. This chapter captured the 13th District bowling tournament championship in March 1945. From left to right are Daphne Allen, Goldie Nichols, Em Lee Lambos (district secretary), Mary Hontzas, and Penny Stryker. In the district, 10 teams usually competed, but the AHEPA today still has national and district bowling tournaments. (Courtesy of Em Lee Lambos.)

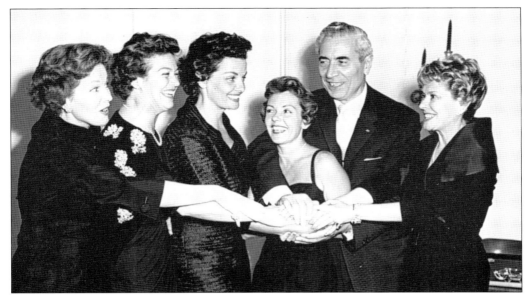

Hollywood supported international organizations in charity fund-raising at the WAIFS Ball of the World Adoption International Foundation at the Conrad Hilton Hotel in 1958. From left to right are June Travis Friedlob, Martha O'Driscoll Appelton, actress Jane Russell, Dorothy Lee Birsbach, Andrew Fasseas, and June Clyde Freeland. Part owner of Boysen White Baking Company, Fasseas also held public office as the Illinois State revenue director under Gov. William G. Stratton. (Courtesy of Milton and Catherine Fasseas.)

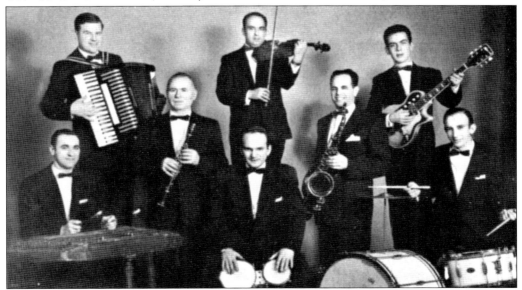

A 1957 business card depicts the Katsikas Orchestra with, from left to right, John L. Katsikas at santouri (cimbalom or hammer dulcimer), Ray Janas at accordion, Lucas Katsikas on clarinet, Sam Fotopoulos on violin, Ed Drucker (American drummer), George Poulos on saxophone, Spiro Skouras on guitar, and Chris Fotopoulos (Greek drummer). Continuing the tradition of Lucas Katsikas, the band played for several generations of Greeks in the 1950s, 1960s, and 1970s. (Courtesy of the Hellenic Museum and Cultural Center.)

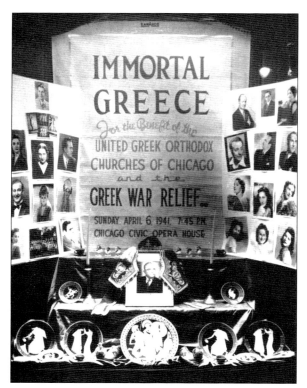

The Greek War Relief benefit show of April 6, 1941, "Immortal Greece," was performed in support of the war effort. The music covered the broad spectrum of Greece's contribution to Western culture. The last portion of the program dealt with the heroic effort of Greece to stave off Nazi invaders. (Courtesy of Harold and Faye Peponis.)

An original political cartoon by Cecil Jensen, "Spartan Courage," appeared in the *Chicago Sun* in 1940, before American involvement in World War II. The title, "Reviving an Ancient Code," refers to the Spartan mother's command to her warrior son: "With your shield or on it." (Courtesy of James Michael Mezilson.)

Marcos Bozzaris, an opera about a Greek War of Independence patriot, was performed to benefit the United Greek Orthodox Churches. The soloists, directors, and conductors were Greek American professionals, and the casts and choruses were generally composed of members from the Greek Orthodox community. Other operas followed the same pattern. (Courtesy of Harold and Faye Peponis.)

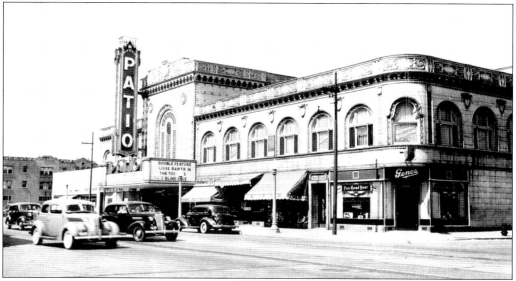

On January 29, 1927, dreams of John Mitchell (Michelopoulos) and his two brothers, William and George, were realized when the Patio Theater, a 1,600-seat movie palace located on Chicago's northwest side at Irving Park Road and Austin Boulevard, opened with a magnificent organ, vaudeville acts, and top-rated movies. Although the theater closed in the early 1980s, it still stands and is on the Chicago historical landmark list. (Courtesy of Margaret E. Boylan.)

Three arts, customs, and culture converge in this 1999 photograph by Chicago professional Trent Sarantis, who depicts the photograph of his uncle Panayoti, who died in 1993, on a cross-stitched tablecloth with the picture behind komboloi (worry beads). (Courtesy of Sophia and Trent Sarantis.)

With the scoreboard in the background, Lane Technical High School principal George L. Mazarakos throws out the ceremonial first pitch at Wrigley Field on Memorial Day 1993 in commemoration of the school's 85th anniversary. While working as a carpenter, he earned a bachelor's degree in classical languages and a master's degree in educational administration. (Courtesy of George L. Mazarakos.)

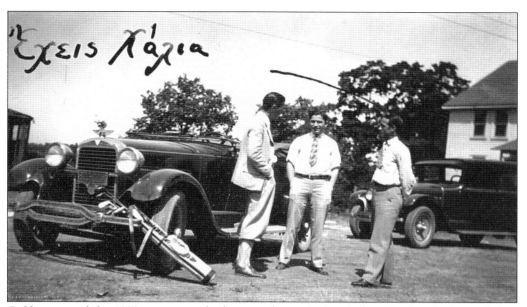

Golfing around the 1920s was not only the sport for professionals, but Greeks who learned they could be just as avid and expert as anyone else. It is not clear who makes the comment *Exeis xalia* (literally translated as "You've got problems"), but it appears to be poking fun at the golfers. (Courtesy of George Sinadinos.)

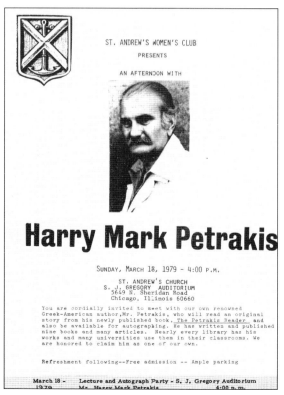

An advertisement for a March 18, 1979, reading sponsored by the St. Andrew's Greek Orthodox Church Women's Club features acclaimed Greek American Chicago author Harry Mark Petrakis, guest speaker to give a reading from *The Petrakis Reader*. Petrakis, who grew up at SS. Constantine and Helen Greek Orthodox Church on the South Side, uses Chicago as the setting for many of his stories, which often look at life from an immigrant's eyes. (Courtesy of St. Andrew's Greek Orthodox Church.)

Planning the 1970s "Evening in Fantasia" benefit are, from left to right, Thalia Zane, Rita Gregory, Mrs. C. W. Economos, and Katherine Bugelas. The Zane name may be familiar because Mrs. Zane is the mother of film stars Billy and Lisa Zane. (Courtesy of St. Andrew's Greek Orthodox Church.)

On September 27, 1980, the St. Andrew's Greek Orthodox Church Women's Club presented the original creations of Greek American designer Becky Bisoulis (standing) at the St. Andrew's Fashion Show. Seated to the right of Bisoulis are Yvonne Philippidis, president, and Irene Tzakis, past president (far right). For many years, these fashion shows served as a source for philanthropic fund-raising, and the women's clubs were transformed into Ladies Philoptochos Societies. (Courtesy of Yvonne Philippidis.)

With its coach James Economakos, Chicago AHEPA chapter No. 46 was crowned champion of the 1965 NHIBT. Originating in 1931, the NHIBT was initially founded to take the sting out of the economic woes of the nascent Great Depression. At the outset, basketball helped assimilation, but during the 1950s through 1970s, the NHIBT and its annual dinner dances stimulated ethnic unity. (Courtesy of Phil Bouzeos.)

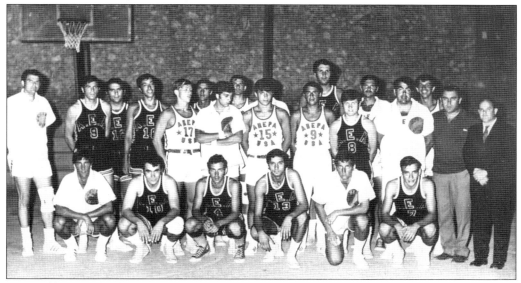

Pictured here is the first Greek American AHEPA basketball team to travel to Greece for the 1970 supreme convention with their coach Lou Cotronis (far right). The team in the dark uniforms is the entry from Greece. (Courtesy of Roy Dolgos.)

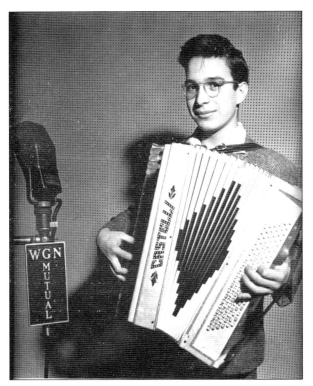

Philip Kaporis, age 13, plays his accordion around 1943 at a WGN Mutual Radio broadcast. Demonstrating Hellenes' commitment to helping others through membership in diverse organizations such as the Imperial Council of the Ancient Arabic Order of the Nobles of the Mystic Shrine (Shriners), Kaporis became a member in 1974. Kaporis was a longtime member and deputy of the office of Cook County sheriff. (Courtesy of Irene Kaporis.)

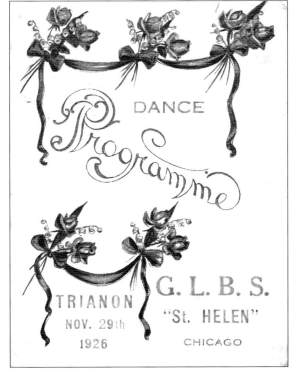

A November 29, 1926, dance program from the GLBS—the women's auxiliary of SS. Constantine and Helen Greek Orthodox Church—features the location of the Trianon, a famous ballroom like the Aragon, both of which were owned by the Karzas brothers, prominent Greek Chicagoans. (Courtesy of George Sinadinos.)

COLUMBIA UNIVERSITY IN THE CITY OF NEW YORK

PULITZER PRIZE NOMINATION

WE WISH TO ACKNOWLEDGE YOUR NOMINATION OF

Lily Venson

FOR A PULITZER PRIZE IN JOURNALISM

We appreciate the interest which prompted you to bring an example of distinguished journalistic achievement to the attention of the University.

Awards are made by the Trustees of Columbia University on the recommendation of the Advisory Board and are announced on the first Monday in May. All exhibits become the property of the University.

Secretary, Advisory Board on the Pulitzer Prizes

We received the following material on February 15, 1973:

☒ Nomination form ☒ Biography ☒ Photo ☒ Exhibit Late Entry
☒ Your entry is complete.
☐ Your entry is incomplete. Please submit missing material.

Lily Pagratis Venson (Voutsanesis), a Chicago newspaper reporter, over a seven-year span produced 100 articles in a community crusade to block high-rise construction at Pratt and Western Avenues in Chicago. Her efforts helped save 100 acres of Edgewater golf land for Warren Park and gained her a Pulitzer Prize nomination on February 15, 1973. (Courtesy of Lily Pagratis Venson.)

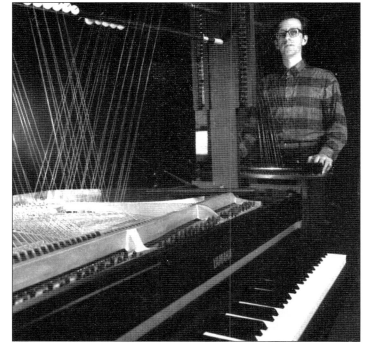

Perry Venson (Petros Voutsanesis), pictured in 1990, created the bowed piano by stringing the strings vertically, outside the sound box of a conventional piano. Because of the new sound produced, Venson was asked to perform in New York City in a concert for musicians who had created new musical instruments. (Courtesy of Lily Pagratis Venson.)

103

Aris Angelopoulos (1917–1988), editor and owner of the *Greek Press* (1962–1988), brought the newspaper to prominence in America. Born in Athens, he graduated from the Commercial and Economic School of Athens and the Academy of Political Science, becoming a journalist for two Athens newspapers. After World War II, he came to the United States, covered the creation of the United Nations, attended Columbia University, and graduated Northwestern University's Medill School of Journalism. (Courtesy of the Andrew T. Kopan collection.)

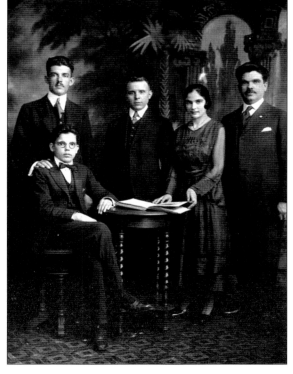

A prominent family in intellectual and cultural activities was the Matsoukas family, seen here in 1920. Siblings who emigrated are, from left to right, Nick (seated), Anthony, Silas Petropoulos (a cousin), Martha, and Peter. Nick (1903–1979), a University of Chicago graduate, became a journalist, founded the AHEPA tuberculosis sanitarium in New Mexico, was publicity director for Greek War Relief and for Skouras Theaters in New York, and wrote from Athens for the *Greek Press*. (Courtesy of the Andrew T. Kopan collection.)

Founded by George C. Grachis in 1922, the Greek Record Company remained in existence into the Great Depression. The Greek Record Company was the only one of its kind in Chicago. Throughout Greektown, music shops, like the Elliopulos Brothers at 803 South Halsted Street, proliferated and provided a vital link in the Greek community. (Courtesy of Steven Frangos and the Andrew T. Kopan collection.)

Chicago's Greek American journalists were prolific during the century. Seen here in the 1970s, Nicholas Philippidis served as editor of the *Greek Star* for 41 years (1953–1994). The newspaper has been in publication since 1904. (Courtesy of Yvonne Philippidis.)

Celebrated author Harry Mark Petrakis and journalist James Michael Mezilson stand before a new exhibit that opened on June 3, 2007, at the Hellenic Museum and Cultural Center, where Petrakis was invited to speak. (Courtesy of Constantine Bacil and James Michael Mezilson.)

Regular journalists for decades for the *Greek Press* newspaper, James Michael Mezilson, Stacy Diacou, and Mark Tiniakos gather around the early 1980s at a gala event. Diacou served as editor in chief for the 1982 *Hellenism in Chicago*, a volume documenting some of the history of Greeks in Chicago. The volume also supported the causes of the United Hellenic American Congress (UHAC), founded by Andrew A. Athens. (Courtesy of the Andrew T. Kopan collection.)

A series of athletic events devoted to youth development, the Junior Olympics has been sponsored by the Greek Orthodox Metropolis of Chicago and held on the grounds of SS. Constantine and Helen Greek Orthodox Church, Stagg High School, and Moraine Valley Community College in suburban Palos Hills. Greek youth are depicted with simulated Olympic torch in 1996. (Courtesy of Jessica Tampas and the Andrew T. Kopan collection.)

George Kontos, second-generation Hellene, played for the New York Yankees' minor-league affiliate the Tampa Yankees in 2007. He attended Northwestern University and Niles West High School in suburban Skokie. Like so many Greek American athletes, he carries the pride of such notables as former Chicago Blackhawk Chris Chelios, also a Chicago area product, Milt Pappas, former Chicago Cubs pitcher, and Johnny Morris, former Chicago Bears receiver. (Courtesy of Theodora and Nick Kontos.)

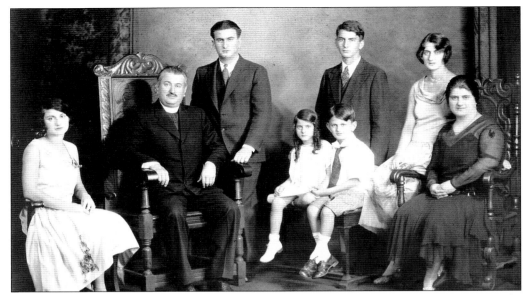

Perhaps the most famous of Greek American writers, Harry Mark Petrakis was the product of a dynamic religious family of the SS. Constantine and Helen parish: from left to right, (first row) Tasula, Rev. Mark (Marcos) Petrakis, Irene, Harry, and Presbytera; (second row) Daniel, Manuel, and Barbara. A prolific writer of over 20 books, Petrakis has held university teaching posts, including the prestigious Nikos Kazantzakis Chair at San Francisco State University. (Courtesy of the Andrew T. Kopan collection.)

Beloved state senator Adeline J. Geo-Karis (1918–2008) was born in Greece, immigrated to the United States at age four, and attended Northwestern University and DePaul University College of Law. Pictured here in 1993, she was one of the first female attorneys in the Judge Advocate General's Corps of the U.S. Navy and the second Greek woman recognized to the bar in Illinois. She served as state representative (1973–1979) and as state senator (1973–2007). (Courtesy of George L. Mazarakos.)

Nine
NOTABLE GREEKS IN CHICAGO

Journalist Terry Poulos (left) is pictured with Eric Karros (center) and former Illinois gubernatorial candidate and Chicago Public Schools superintendent Paul Vallas at a 2003 fund-raiser at the Greek Islands Restaurant in Greektown. Karros, a broadcaster with the Los Angeles Dodgers, played first base for the Chicago Cubs and came to within four outs of the World Series. After Vallas's loss, he experienced success in Philadelphia and New Orleans as school superintendent. (Courtesy of Terry Poulos.)

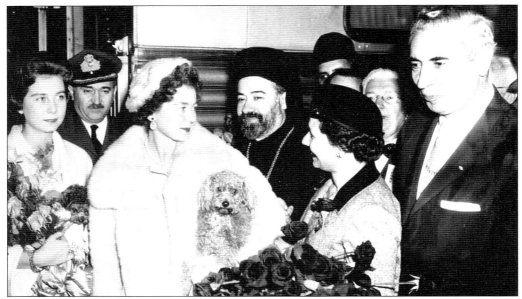

On the occasion of an official state visit in November 1953, from left to right, Princess Sophia and Queen Frederika of Greece are met at the union train station in Chicago by His Grace Bishop Ezekiel of Chicago and Angelyn and Andrew Fasseas. Since Greeks first started coming to the United States, they were factionalized between those loyal to the monarchy (royalists) and those against. The Greek monarchy would survive another 14 years. (Courtesy of Milton and Catherine Fasseas.)

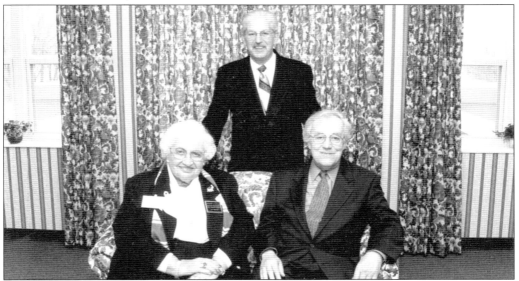

At an open house in 2002 for the Greek American Rehabilitation and Care Center in Wheeling, state senator Adeline J. Geo-Karis, George Lekas (center), and Dr. Theodosis Kioutas pause for a photograph. Previously another group, Sotiria, had begun planning a center in the 1950s and 1960s, but the Greek-American Nursing Home Committee, incorporated in 1984, with Kioutis as its president, renewed efforts and brought the center to reality in 2001. (Courtesy of George Lekas.)

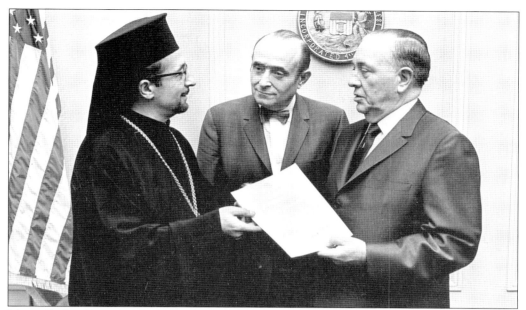

Mayor Richard J. Daley (right) greets Pierre DeMets and His Grace Bishop Timotheos around the 1960s and presents them with a proclamation celebrating Greek Independence Day and honoring the contributions of Greeks to the life of Chicago. (Courtesy of the Hellenic Museum and Cultural Center.)

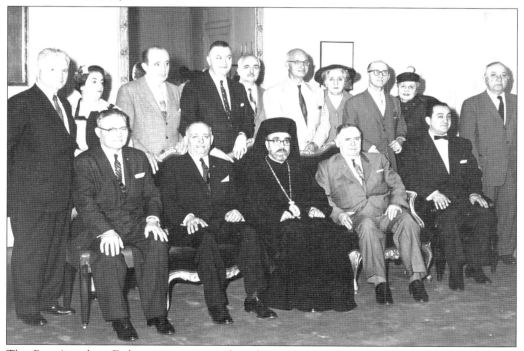

The Pan-Arcadian Federation executive board visits with His Eminence Archbishop Iakovos around 1964 on the occasion of the federation's donation of a gymnasium to St. Basil's Academy in Garrison, New York. (Courtesy of Harold and Faye Peponis.)

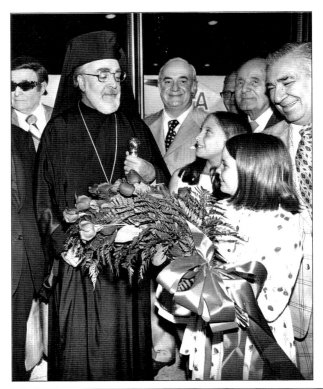

Greeting His Eminence Archbishop Iakovos of North and South America at O'Hare Airport in 1964 are, from left to right, Pierre DeMets, Andrew A. Athens, Arthur H. Peponis, Paul Demos, and George Marks. (Courtesy of Harold and Faye Peponis.)

A 1968 telegram from His Eminence Archbishop Makarios of Cyprus expresses regret over the death of Charles J. Chiakulas, who had been active in organizing free trade unions in Cyprus since 1955. Upon his return from Cyprus, Chiakulas, along with Dr. Christ Costis, Dr. Theodosis Kioutis, and Basil Portocalis, helped form the Justice for Cyprus committee, which is still active in America, particularly following the 1974 invasion of Cyprus. (Courtesy of James Newport Chiakulas.)

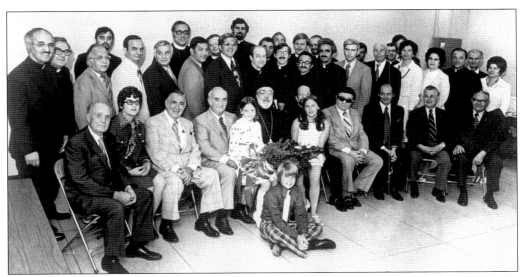

A moving force at the national level was the meeting of the Biennial Clergy Laity Congress in 1975. In Chicago, laity who participated in leadership roles are pictured here, from left to right, (seated) Paul Demos, Eleni Huszath, George Marks, Andrew A. Athens, His Eminence Archbishop Iakovos, His Grace Bishop Timotheos, Pierre DeMets, the Greek consul, Theodore Karras, and Arthur Peponis. Among those standing are Rev. Manousos Lionidis, Rev. Throdore Thalassinos, Sam Stavrakas, Rev. Alexander Karloutsos, Andrew Nichols, Rev. Emmanuel Vergis, Tom Costopoilos, Rev. Dennis Strouzas, Rev. George Skoulas, Rev. Athenagoras Anesti, and Rev. Demetrios Treantafeles. (Courtesy of Harold and Faye Peponis.)

Irene Antoniou (left), philanthropist and advocate for the arts, presents Maria Pappas, Cook County treasurer, with the Heritage Award in 1998, honoring her contributions to the preservation of Greek American heritage. Antoniou, founding chair of the GACS advisory board, was a recipient of the 1996 Sydney R. Yates Advocacy Award. She was at the forefront of campaigns to save the National Endowment for the Arts in 1989 and 1994. (Courtesy of John Psiharis.)

In 1991, Nicole Tsongas, the wife of Massachusetts senator Paul Tsongas, visited with executive director of GACS John Psiharis (left) and Dr. Michael Bakalis, then the president of Triton College and a former gubernatorial candidate, during a fund-raiser for GACS. For a time, the election for governor pitted two Greek candidates against Gov. Jim Thompson. (Courtesy of John Psiharis.)

Associations begun early in life in the Sons of Pericles, the youth auxiliary of the AHEPA, endured as, from left to right, Hon. Samuel C. Maragos, James Michael Mezilson, Angelo G. Geocaris, and Hon. Nicholas J. Melas lunch in Greektown's Santorini Restaurant in 1992. (Courtesy of James Michael Mezilson.)

Elect

JAMES A. GEROULIS

Democratic Candidate for

JUDGE

of the

MUNICIPAL COURT

PRIMARY: TUESDAY, APRIL 13, 1954

Be Sure to Vote the SEPARATE Judicial Ballot
Whether You Vote by Paper Ballot or by
Voting Machine

VETERAN WORLD WAR II

 83 (over)

While this palm card's one side advocates voting for James A. Geroulis for judge of the municipal court in the April 13, 1954, election, of equal importance are the candidates supported on the reverse: U.S. senator Paul Douglas, trustee of the sanitary district John A. Cullerton, county clerk Richard J. Daley, judge of the county court Otto Kerner, president of the county commissioners Daniel Ryan, and county commissioners Arthur X. Elrod and John J. Touhy. All the candidates above have achieved lasting fame, notoriety, or disgrace depending upon their subsequent fortunes. Perhaps the most outstanding name on the list is Richard J. Daley, who would go on to become the longest serving Chicago mayor until his son eclipsed the mark. Having survived the trials of immigration, labor, and acculturation, Hellenic Americans had finally become politically connected and activists. (Courtesy of Maria Karamitsos.)

VOTE DEMOCRATIC

U. S. Senator
☒ PAUL H. DOUGLAS

State Treasurer
☒ DAVID F. MALLETT

Supt. of Public Instruction
☒ MARK A. PETERMAN

Trustees Sanitary District
☒ JOHN A. CULLERTON
☒ FRANK W. CHESROW
☒ CASIMIR GRIGLIK

County Clerk
☒ RICHARD J. DALEY

Judge of the County Court
☒ OTTO KERNER

County Assessor
☒ FRANK KEENAN

Sheriff
☒ JOSEPH D. LOHMAN

Recorder of Deeds
☒ JOSEPH F. ROPA

Treasurer County of Cook
☒ HERBERT C. PASCHEN

Clerk of the Criminal Court
☒ SIDNEY R. OLSEN

Clerk of the Probate Court
☒ BERNARD J. KORZEN

Judge of the Probate Court
☒ ROBT. JEROME DUNNE

Superintendent of School
☒ NOBLE J. PUFFER

Board of Appeals
☒ ARTHUR P. MURPHY
☒ GEORGE M. KEANE

Pres. County Commissioners
☒ DANIEL RYAN

County Commissioners
☒ DANIEL RYAN
☒ ARTHUR X. ELROD
☒ JOHN J. DUFFY
☒ ELIZABETH A. CONKEY
☒ EDWARD M. SNEED
☒ CHRIST A. JENSEN
☒ CLAYTON F. SMITH
☒ JOHN J. TOUHY
☒ JAMES F. ASHENDEN
☒ FRANK BOBRYTZKE

Municipal Court Bailiff
☒ WILLIAM G. MILOTA

Municipal Court Clerk
☒ JOSEPH L. GILL

Chief Justice Municipal Court
☒ RAYMOND P. DRYMALSKI

Judges Municipal Court
☒ HARRY P. BEAM
☒ C. V. CWIKLINSKI
☒ HYMAN FELDMAN
☒ JAMES A. GEROULIS
☒ ERWIN J. HASTEN
☒ EMMETT MORRISSEY
☒ GEORGE L. QUILICI
☒ JAY A. SCHILLER
☒ FRED W. SLATER
☒ JOHN J. SULLIVAN
☒ E. L. WACHOWSKI
☒ ALFONSE F. WELLS

To Fill Vacancies
☒ DAVID LEFKOVITS
☒ JOHN T. ZURIS
☒ WILLIAM J. TERRELL

For over 50 years, Katherine G. Valone, educator and journalist in the Greek ethnic media, focused on church and community events. A graduate of the University of Chicago, she served on the SS. Constantine and Helen Greek Orthodox Church parish council and chaired the Koraes School Board. Serving in many capacities in the Greek American community, she established a Phosadelphia mission program that contributed financial aid to support the needy in other countries. (Courtesy of the Andrew T. Kopan collection.)

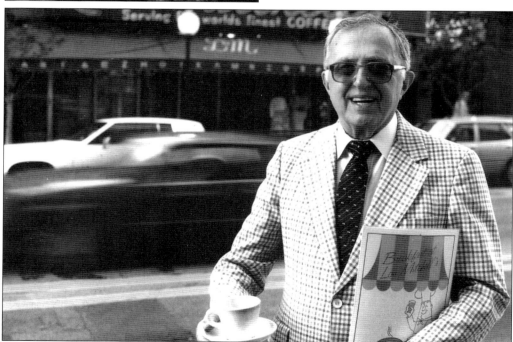

Another fixture of the restaurant trade, world-famous Lou Mitchell's at 563 West Jackson Boulevard serves as the backdrop for restaurant owner Louis W. Mitchell in 1992. (Courtesy of Louis G. Apostol.)

A community stalwart, Sam Stavrakas (seen in the late 1970s), a second-generation Greek American, inherited his father's burgeoning laundry business and developed it into a leading commercial laundry serving restaurants and other businesses. Cosmopolitan Laundry and Linen Supply was at one time one of 17 Greek-owned commercial laundries in Chicago. (Courtesy of the Andrew T. Kopan collection.)

Many patrons have been helped to drown their sorrows at the Cubby Bear Lounge, a longtime landmark across the street from Wrigley Field. Seen here in 2008, the Cubby Bear has been under the ownership of the Loukas family, and the names of Gus G. Loukas and Sophia Loukas have been memorialized in the building's facade. (Author's collection.)

In 1981, Dr. Angeline P. Caruso, interim superintendent of the Chicago Public Schools system, was presented with the Socratic Award for Excellence in Education by the UHAC and by the Hellenic Council on Education (HCE) for exemplary leadership in restoring the school system to economic solvency while maintaining a focus on quality education. Caruso is flanked by then bishop of Chicago Iakovos and Chicago mayor Jane Byrne. (Courtesy of the Andrew T. Kopan collection.)

Nicholas J. Melas stands in front of the Melas Centennial Plaza and Fountain, which honors his contribution in service to the Metropolitan Sanitary District of Greater Chicago. When he was elected in 1962, he was the first Greek American elected to an executive office in Cook County. Melas was subsequently reelected four times for a total of 30 years and served as president for 18 of those years. (Courtesy of the Andrew T. Kopan collection.)

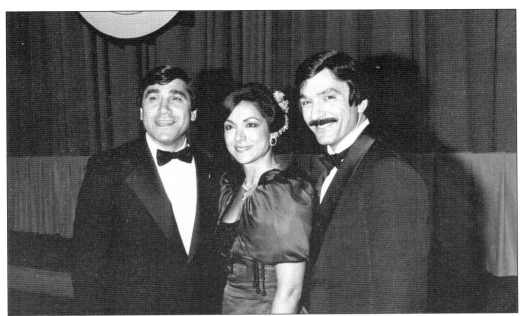

From left to right, Nicholas S. Gouletas, then general partner of Lake Point Tower, Evangeline Gouletas, vice chairman of American Invesco, and Victor Goulet, chief executive officer of ERA Real Estate, pause during one of several charity events. Lake Point Tower was the only high-rise east of Lake Shore Drive and featured a unique curved-glass design. Founded in 1969, American Invesco converted the building to condominiums in 1988. (Courtesy of the Andrew T. Kopan collection.)

Chicago mayor Michael A. Bilandic (right) honors DePaul University professor Andrew T. Kopan in 1977 for his contribution to *Historic City: The Settlement of Chicago*, a bicentennial publication project of the city. Pictured with wife Alice, Kopan received the book in ceremonies at the Bismarck Hotel. (Courtesy of the Andrew T. Kopan collection.)

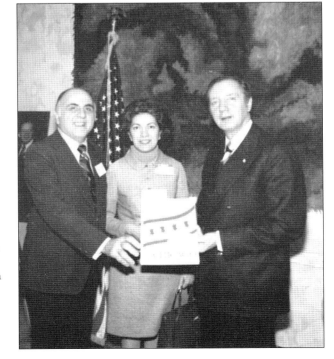

Alexander Sarantos Tremulis (1914–1991), an influential automotive designer born in Chicago, was chief of Ford advanced styling from 1952 to 1963. Previously he was chief stylist for Auburn-Cord-Deusenberg in 1936 and was responsible for the design of the 1948 Tucker Torpedo. In 1947, in response to the Roswell, New Mexico, events, he made the first documented drawings of what came to be known as flying saucers. His design Operation Dyna-Soar was the precursor to the space shuttle. (Courtesy of Steve and Sondra Tremulis.)

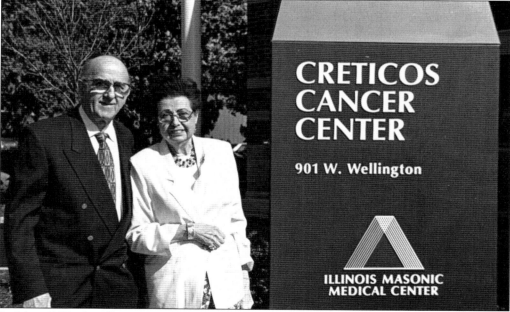

In May 1997, the Illinois Masonic Medical Center dedicated a cancer center naming it in perpetuity in honor of Dr. Angelo P. Creticos, in recognition of his 30-year medical research career. His direction pioneered clinical cancer preventive medicine as well as psychosocial support programs for cancer patients and their families. Dr. Creticos has also spearheaded worldwide diabetes research that is now called the Chicago Project at Rush Medical Center. A large portrait of Dr. Creticos and his wife Anastasia hangs in the reception entry area at the center. (Courtesy of the Andrew T. Kopan collection.)

Ten

PRESERVATION AND THE BACKWARD GLANCE TO THE HOMELAND

Leon Marinakos, former manager of product development and engineering for Hobart Corporation, is perhaps better known for hundreds of lectures illustrated with color photography of Greece, antiquity, the Byzantine world, and Greek Americana. In 1976, in recognition of his work projecting Hellenism and Greek culture, the Greek government appointed him honorary cultural attaché to the consulate general of Greece, a position he continues to serve. (Courtesy of the Andrew T. Kopan collection.)

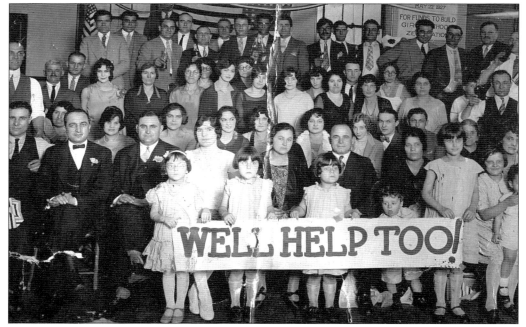

As early as May 27, 1927, the First American Campaign launched by the Brotherhood of Zevgolatio worked to raise funds to build a girls' school in Greece. Recognizable adults in the first row are, from left to right, James Panagakis (second from left), Spiro Pecharis, and Chrisoula Pecharis (third and fourth from left). Zevgolatio was a village outside Tripolis, Greece. (Courtesy of Diane and William Rouman.)

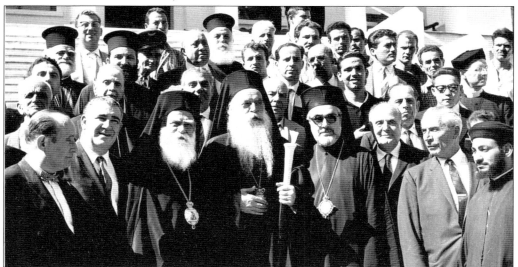

Four prominent Greek Chicagoans visit with clergy at a break in an AHEPA convention in Greece around 1965. From left to right are Pierre DeMets, George Marks, unidentified, His All Holiness Ecumenical Patriarch Athenagoras, His Eminence Archbishop Iakovos of North and South America, Paul Demos (attorney), and Andrew Fasseas. Paul Demos was the first Greek attorney in Chicago and a founder of St. Andrew's Greek Orthodox Church on Sheridan Road. (Courtesy of Milton and Catherine Fasseas.)

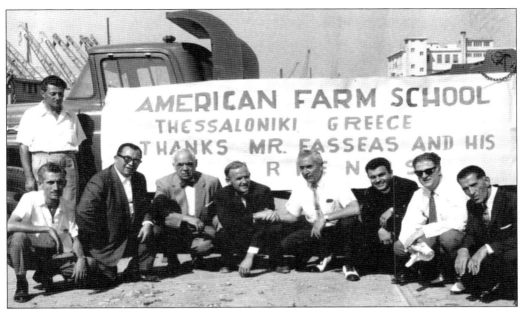

In an outreach effort to assist Greeks in road building and other construction projects, Andrew Fasseas (fourth from right) delivers a donation of money and equipment from Greek American Chicagoans to the American Farm School in 1962. The complete banner reads, "American Farm School Thessaloniki Greece Thanks Mr. Fasseas and His Friends." (Courtesy of Milton and Catherine Fasseas.)

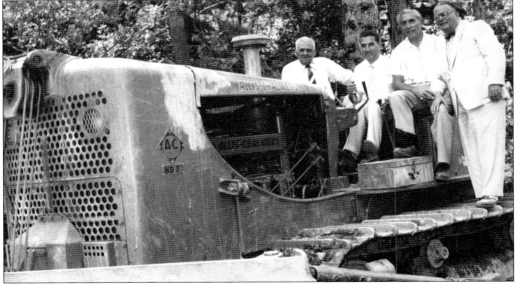

A donation of road-building equipment in 1958 was to assist Greeks in building roads in mountainous areas of Greece. Illinois senator Everett Dirksen was also involved in the effort, but 5 percent came from Greek American fraternal societies with combined funding between the United States and Greek governments. These efforts were designed not only to assist recovery from World War II and the Civil War but also to achieve greater modernization. (Courtesy of Milton and Catherine Fasseas.)

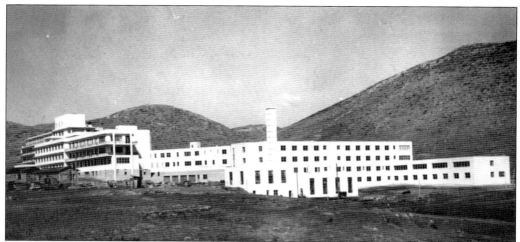

Through the fund-raising efforts of the Pan-Arcadian Federation, the group launched an excursion in 1953 to dedicate this badly needed, state-of-the-art hospital in Tripolis, Greece, the heart of Arcadia. The ethos of beneficence, however, was quite commonplace among Greeks of all generations, but because Greece was then just recovering from the brutalities of a world war and a civil war, the outpouring of aid was especially meaningful. (Courtesy of Harold and Faye Peponis.)

On a bridge overlooking the Chicago River around 1965, screen actor George Chakiris, an Oscar winner for his role in the musical West Side Story, grants an interview to reporter Lily Pagratis Venson for Lerner Newspapers. Venson was a reporter (1963–1973), public information officer for the Cook County Governing Commission (1973–1976), and public information officer for the Illinois Department of Children and Family Services (1980–1991). (Courtesy of Lily Pagratis Venson.)

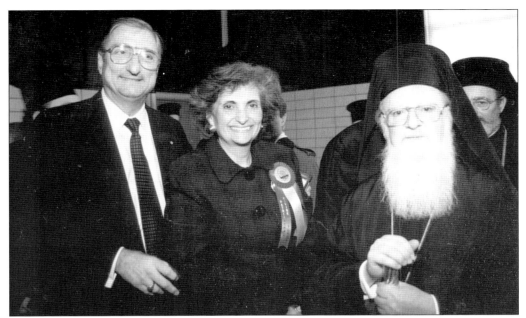

With His All Holiness Ecumenical Patriarch Bartholomew are Anthony and Marianne Nichols on the occasion of a historic visit to the United States in 1997. Pictured here in the Basil E. Stevens Auditorium of St. Andrew's Greek Orthodox Church, Bartholomew has come to be known affectionately as the "green patriarch" because of his support for the environment and because of his leadership in raising the consciousness of Orthodox Christians about the responsible use of natural resources. (Courtesy of St. Andrew's Greek Orthodox Church.)

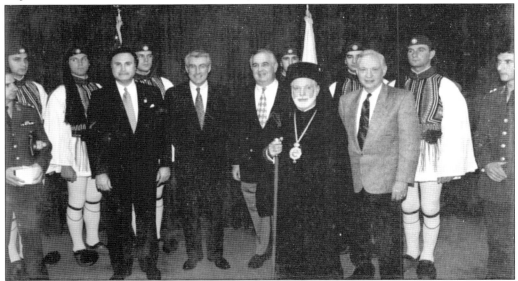

The 1992 Greek Independence Day celebration is recognized at the State of Illinois Building with, from left to right, Louis G. Apostol, public administrator of Cook County; Gov. Jim Edgar; John Marks, chief executive officer and chairman of the board of Mark IV Realty; His Grace Bishop Iakovos; and James Regas, representative of UHAC. In the background in full regalia stand six evzone guards who were brought in from Greece for the occasion. (Courtesy of Louis G. Apostol.)

From left to right, Constantine, Athena, and George Davros on their visit to Greece in 2005 have the greatest icon of Western culture, the Parthenon, in the background. For any Hellene, modern or ancient, European or American, the Parthenon serves as a reminder of the height of ancient Greek civilization and informs the aspirations of Greek youngsters toward achieving the ideals of Hellenism. (Author's collection.)

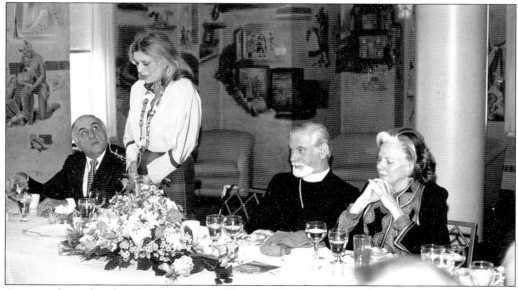
As part of a multicultural movement in Chicago, Greek actress and minister of culture Melina Mercouri addresses a luncheon hosted by the UHAC in 1984. Seated are, from left to right, DePaul University professor Andrew T. Kopan, His Grace Bishop Iakovos, and Margaret Papandreou, wife of the Greek prime minister. (Courtesy of the Andrew T. Kopan collection.)

Officially opened on May 3, 1992, the Hellenic Museum and Cultural Center showcases many exhibits including religious and folk art and the immigrant experience. This 1993 photograph includes Themi Vasils (second from left), president of the board of directors, Theodora Vasils, director of the museum bookstore, and James Michael Mezilson, treasurer, associate curator, and one of the founders. (Courtesy of the Andrew T. Kopan collection.)

The Oxi Day celebration commemorates the October 28, 1940, rejection by Greece—"No"—of Adolf Hitler's ultimatum as Nazi troops poised to invade Greece during World War II. The defiance and heroism has marked a cause for celebration in Greek American institutions. Decades after the event, the day is memorialized in Greek schools and churches. (Courtesy of the Andrew T. Kopan collection.)

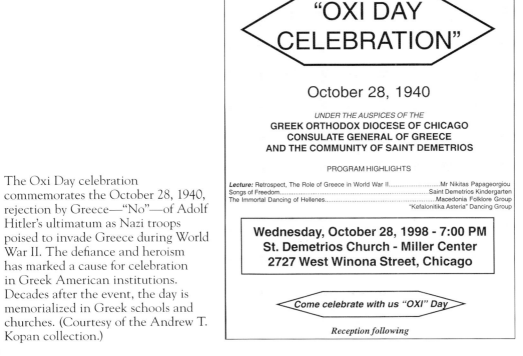

Across America, People are Discovering Something Wonderful. Their Heritage.

Arcadia Publishing is the leading local history publisher in the United States. With more than 3,000 titles in print and hundreds of new titles released every year, Arcadia has extensive specialized experience chronicling the history of communities and celebrating America's hidden stories, bringing to life the people, places, and events from the past. To discover the history of other communities across the nation, please visit:

www.arcadiapublishing.com

Customized search tools allow you to find regional history books about the town where you grew up, the cities where your friends and family live, the town where your parents met, or even that retirement spot you've been dreaming about.